View from a Sketchbook

nature through the eyes of

MARJOLEIN BASTIN

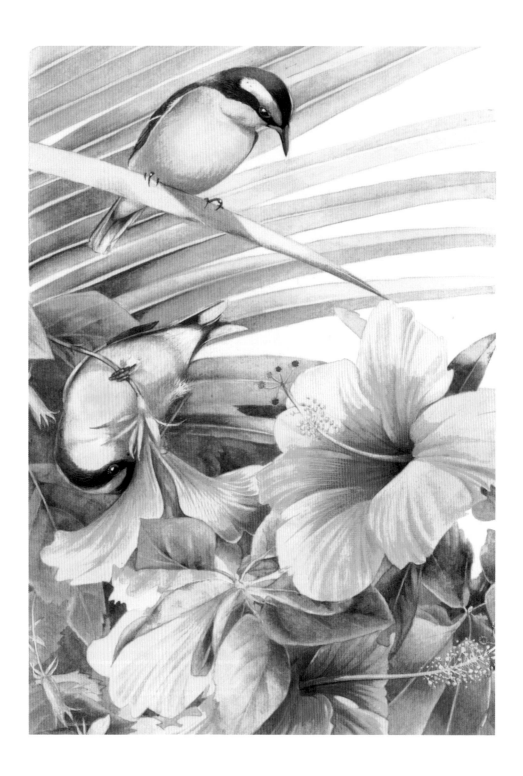

View from a Sketchbook

nature through the eyes of

MARJOLEIN BASTIN

with TOVAH MARTIN

Stewart, Tabori & Chang
New York

CONTENTS

Introduction
· 6 ·

The Prairie
· 9 ·

Spring

Kearney, Missouri
· 13 ·

The Garden Surrounding the House
· 16 ·

Time Reigns over Everything
· 20 ·

Killdeer
· 24 ·

Painted from Memory
· 29 ·

Drawing from Nature
· 30 ·

The Bird Feeder
· 42 ·

Summer

Holland: The House
· 49 ·

Nesting Boxes
· 57 ·

Birds of a Feather
· 61 ·

The Herb Garden
· 65 ·

Into the Woods
· 74 ·

The Desk in the Studio
· 80 ·

Missouri: Making a Walk
· 85 ·

Prairie Canaries
· 96 ·

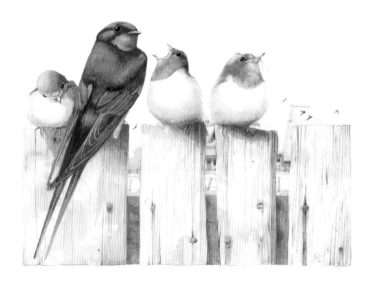

Autumn

Missouri: The Sweet Time

· 99 ·

Hallmark Preserve

· 102 ·

The Goose Pond

· 113 ·

Winter

Missouri: Adaptations

· 119 ·

The Cardinal

· 134 ·

Grand Cayman

· 137 ·

Missouri: Talking Back and Forth

· 147 ·

Last Word

· 159 ·

Introduction

Before I met Marjolein Bastin, the prairie, in my eyes, was nothing beyond a field of grasses. I knew that such a place existed; I knew that the Midwest was its primary homeland in this country; and I was aware that the habitat is rapidly diminishing. But I hadn't witnessed the rosinweed towering over its domain, or watched a goldfinch couple foraging through acres of seed heads at high noon, sunlight glinting on their feathers. I had never seen the way the big bluestem ripples with color as it sways in autumn. I had never understood the way the changing light of the sky is reflected in the land. I learned about these things through Marjolein.

Like many other Americans, I was first introduced to Marjolein Bastin through the Dutch artist's line of illustrated Hallmark cards. I still have the first Marjolein Bastin card that I found—it's a series of profiles of baby owls as seen through a nest hole in a tree hollow. But I kept subsequent cards as well. Drawings of bluebirds wrestling with worms, of autumn leaves, birdhouses, and bird's nests, are tucked into the pages of books as bookmarks; they're propped beside my desk, ready to vanquish an onslaught of writer's block. So when *Victoria* magazine asked me to write an article about Marjolein Bastin, I was already familiar with her

signature watercolor style, her uncannily lifelike birds, and animals, and flowers, suffused with color.

That was long before Marjolein restored her tall-grass prairie. She was still living in Holland and hadn't come to Missouri yet, although her art had already captivated Europe. She was illustrating and writing a one-page feature for a broadly circulated Dutch women's magazine, *Libelle* (which means "dragonfly"), an assignment that she's fulfilled faithfully every week for decades, since graduating from the Academy of Arts in Arnhem. When we met, she was illustrating calendars and nature books as well as a children's series featuring Vera the Mouse, a character that Marjolein created.

America discovered Marjolein Bastin and her art when a talent scout from Hallmark happened upon her work while on vacation in Holland. Marjolein and Hallmark became a team in 1992, and that was the beginning of the overwhelmingly well-received Nature's Sketchbook, Marjolein's line of greeting cards, stationery, and home and garden decor items.

We met and became friends shortly after Marjolein and Hallmark joined forces, but I like to think that our paths would have crossed somehow, even without the *Victoria* assignment. As a garden writer, I've spent my life exploring the floral aspects of nature, with a heavy emphasis on heirloom flowers, herbs, and cottage gardens; topics that Marjolein also holds dear. When we phoned back and forth, the conversations were electric—our discussions lingered long and were spiked with strong opinions on everything from environmental issues to gardening topics. So when Marjolein came to live in America, I couldn't resist the invitation to go to Missouri and see what she was up to.

For Marjolein's part, coming to live in Missouri wasn't originally on her list of life goals; it sort of just slipped into her agenda. When Marjolein was invited to visit the Hallmark headquarters, she experienced her first encounter with the prairie. Hallmark owns a land preserve surrounding the retreat site near their headquarters in Kansas City, Missouri. And halfway through the event, Marjolein

escaped the bustle of people to take a solo walk through the preserve. No matter that it was rainy and raw out; she donned proper water-repellent gear and ventured into the grasslands.

That was it. She was smitten, and voiced her appreciation in no uncertain terms. Here were different species of birds, insects, and plants in a setting dramatically unlike her garden in native Holland. As an artist and naturalist, Marjolein fell instantly in love with the prairie, and said so.

When Marjolein is excited about something, her enthusiasm becomes contagious, and things happen. Listening to her express excitement is a memorable experience—if you have a prairie that Marjolein has praised, you're not apt to forget her ardently articulated ode of affection. Which explains how, a year later, when land adjacent to the Hallmark land preserve came onto the market, Hallmark lost no time informing the Bastins of the real estate opportunity. The Bastins bought it immediately and built a home. Then they turned to the land.

THE PRAIRIE

The result of a unique set of environmental factors, the prairie is a phenomenally fine-tuned habitat. The grasslands that we call prairie were formed primarily due to the lack of rainfall in that region of the Midwest. But the prairie also owes its ecology to the soil, and to the winds that sweep across it. The short-grass prairie farther west of Missouri receives just enough rainfall to qualify as a grassland rather than a desert. But Kansas City, where the average annual rainfall is thirty or more inches, can support a tall-grass prairie. And that's what Hallmark and Marjolein strove to restore.

According to *Restoring the Tall-grass Prairie* by Shirley Shirley, "The tall-grass prairie covered 250 million acres of the Midwest for over 8,000 years. This prairie had been dominated by over 30 species of grasses and over 250 forbs [the technical name for flowering plants that are neither grasses, trees, or shrubs] ... By the 1900s this prairie was on the brink of destruction after only half a century of intervention by the steel moldboard plow. There was less than one percent of native prairie remaining in Iowa."

The tall-grass prairie of Missouri is dominated by big bluestem, with several other native grasses intermingling to give it that wonderful, wavy composition that we associate with grasslands. Specially adapted flowering plants are also part of the mix, taking root wherever they can find a niche.

"Gumbo" is what Cliff "Woody" Woodward, who has been overseeing the Bastins' prairie restoration since its inception, calls the soil in that region. To demonstrate what he meant, he scooped up a handful of soil and made a fist. "You can mold it. If you make a ball of moist soil and let it dry, that thing's solid like a rock. This is Clay County, and it earned its name."

I went to visit Marjolein in Missouri a couple of years after the Bastins decided to divide their time between their Holland home and the Frank Lloyd Wright–style house they built in Missouri. That's when I was introduced to Gaston, Marjolein's husband. Prone to blush at the least provocation—most often from delight—Gaston is a quiet man who can balance serious subjects with a generous helping of humor. Deadlines, airport delays, snarled traffic, bad weather, and overflowing plumbing all seem to receive the same good-natured, patient, but efficient response from Gaston. Fond of fast cars and cameras, but also fully conversant about birds, insects, and other elements of the natural world, Gaston keeps Marjolein from drowning in work. On a day-to-day basis, he acts as her agent and manages her schedule. On a deeper level, he is her perfect complement. Although they share the same taste in opera and classical music, he'd really rather talk about favorites in an upcoming Grand Prix than ponder the life cycle of the resident bullfrog. Together, they have two children: Sanna, who owns a gift shop and lives on the farm next door to their Holland home; and Mischa, who is a lawyer and now lives in Kansas City.

By the time Marjolein and Gaston decided to restore the 300-plus-acre property, the land had been nurturing corn and soybeans for generations, and had to be reclaimed. It was a gradual and painstaking process.

The Missouri Department of Conservation was consulted, as well as the Nature Conservancy. The fields were seeded with a specially formulated prairie blend, mowed above prairie seedling height to keep the weeds in check, and seeded again. Big bluestem would eventually play the starring role. But big bluestem, the superstar of the prairie, takes several years to gather the strength and send down the root system necessary to reign supreme. In the meantime, flowering plants such as penstemon, bee balm, liatris, Joe Pye weed, sneezeweed, coreopsis, sunflowers, black-eyed Susan, coneflower, goldenrod, and asters took dominance. Alien species were dissuaded: cosmos, yarrow, bachelor's buttons, dame's rocket, Saint-John's-wort, several clovers, butter-and-eggs, bouncing Bet, and Queen Anne's lace are all on the prairie purists' list of undesirables. Downright weeds

such as wild parsnip and burdock, were also an issue. Queen Anne's lace remains an issue; lovely though the wildflower might be, it doesn't belong. Marjolein is practicing benign methods of control, collecting as many Queen Anne's lace bouquets as she can to prevent further seeding.

The Bastins named their property Blue Skies, and Marjolein never ceases to be struck by the splendor of the place; she has never lost her sense of wonder, which colors all that I am about to tell you. She appreciates the majesty of the big picture, but she cares most about the viceroys, fritillaries, and bobwhites that come to Blue Skies as refugees.

And the same is true for her Holland garden, which is part park, part formal garden, part wildlife habitat. There, Marjolein has created a retrospective in landscape of her childhood garden and cleared paths through the forest so that she can eavesdrop on nature without disturbing its daily routine. There, she records the comings and goings of birds she's known all her life. In Holland, everything speaks her native language; there's an intimacy that she works to make universal.

Marjolein Bastin has a message, she's often told me, and it's hidden between the brushstrokes in every drawing she's ever done. She wants you to share nature with her. She wants you to walk beside her. You don't need a prairie; you don't even need a garden. All you need is to attune your senses, and then go out and explore.

Missouri, September 2002

The smell of the prairie is the aroma of fresh-baked bread. Most people can't smell it, but it's different than the smell of any other combination of grasses. At first, it just made me hungry. Now, it's the essence of home.

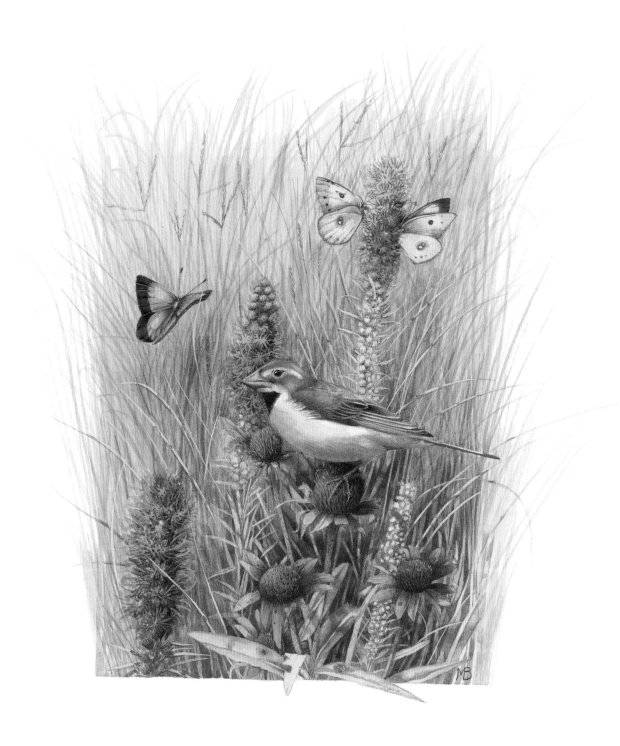

Spring

Kearney, Missouri

You've got to track spring daily to keep up with its fast pace in the Midwest. The buckeye that just yesterday was a nondescript wad of tightly folded leaves fans out like an umbrella today, proclaiming its identity. Buds pop on the violets; spring beauty and ground ivy give the paths on the verge of the prairie a sense of importance that they lose later on.

Most things here move quickly in spring, but not the grasses. First, the penstemons sprout through the heavy soil and swing into the serious business of expanding beyond rosettes. Then, when the penstemons are well under way, when the bee balm has opened shop for the season, the

grasses finally send up a few tenuous blades. Even the big bluestem is in no rush whatsoever to take command of the prairie. Instead, it spends early spring as stubble, gearing up for the big push to come.

There's nothing to wade through in spring except the straw from last year's festivities; the prairie lags behind the rest of creation. But it still engulfs you.

That's what undoubtedly drew Marjolein to Missouri in the first place; the prairie has a lure that could only be described as hypnotic.

Marjolein writes in the morning. In the early hours before dawn I can hear doors softly open and close, and I know she's in her studio. I have been described as having the presence of the world's smallest herd of elephants, but Marjolein's movements are so smooth that your average field mouse makes more commotion. I suspect that she makes an effort to clatter a little when she wants the household to know that she's ready to entertain whatever the day has to offer.

Marjolein isn't a Do Not Disturb sort of person. But because she's mentioned so many times

that writing requires her full energy, I never infringe on her early-morning time. Instead, I go out into the prairie. More accurately, I'm drawn out.

The sheer magnitude of the prairie is enthralling—it engulfs you. It drums itself into your memory bank by repetition: big bluestem, bee balm, coneflower, liatris; over and over again. But against that monotony, there's focus—lives are conceived and lost in the prairie on a daily basis. When I go out into the prairie, I don't mark, as Marjolein does, the wads of fur signifying that a rabbit lost its life to a predator during the night. But I see the pregnant stirring of the grasslands.

For me, the tall-grass prairie is a tapestry, all the plant life woven together with the insects, animals, and birds that make it work as a habitat. Mostly, because I see plants, I notice how they create a harmony; a symphony, Marjolein would call it. But Marjolein has attuned my ears to the sounds of the birds, and she's trained my eyes to look for spiders. She's talked about how the cumbersome bumblebee is batted around the prairie by the wind in its skirts, trying to zero in on its fodder. So I come back to the house with pockets full of snail shells from the parched bank of the gully. Back in Connecticut, I wouldn't come home with anything but seedpods.

Missouri, April 2003

You will not write about the prairie through my eyes, but through your own.

The Garden
Surrounding the House

When Marjolein returns to Missouri from her frequent travels, she always feels an initial sense of displacement. No one senses change more deeply than Marjolein, no one is more sensitive to new stimuli, the chatter of different birds, the subtleties of altering light. As I see it, that's why the house is always filled with bouquets.

Missouri, April 2003

When I come back, at first I can't find my balance. So I open all the doors, I open all the windows, I see the crocuses and tulips, I smell the air and feel the weather on my cheek, and then there's such a joy in me. If I could be an organ, I would play on and on forever.

Now I'm grounded. This place is living in me again. The power, the beauty, the harmony, has a strength that is bonding me here. I know my Missouri family of birds and flowers again.

The house sits atop a series of terraces, an elevated vantage point to survey the surroundings. Since Marjolein is a gardener at heart, as involved in working with nature as in leaving nature to follow its own course, gardens ease the transition between field and facade, merging the home into the land and vice versa. Orderly, neatly kept, sympathetic to (and echoing) the setting, the gardens are a marriage between the flowers that Marjolein is fond of and the mood that is Missouri. As low-maintenance as possible, the design is a simple composition of square and rectangular beds filled with grasses and easy-care perennials such as sedums and heuchera. To

define the space, the beds are hemmed by stone patios. Crab apples and other low-growing trees create shade, and a sense of intimacy. Whereas the flat land of the Midwest can leave you feeling exposed, the trees appeal to your sense of security; they gather you under their wings as the ducks gather their ducklings.

There is no garden between Marjolein's studio window and the prairie that she continually monitors. But from most other rooms the prairie view is framed by gardens. In the kitchen, living room, and dining area, the windows stretch from floor to ceiling. There you can watch the pond, with its pergola, and the trails. On the other side of the house, away from the prairie, the kitchen and breakfast nook overlook a water sculpture that sends a waterfall sheet rushing from a wall of stone. The flower beds are planted with cheerful bulbs in spring. The blooms fill vases in every room of the house.

Missouri, April 2003

Actually, we don't have many bulbs in our gardens in Holland. I see more tulips in Kansas City than in Holland. And every year, I see more than ever the beauty of bulbs.

But really, when you plant a garden, you aren't planting bulbs and flowers, you're planting memories. It's more than just pretty flowers. And there must be surprises in it. There must be a tiny mistake in it, a clumsy thing. If there are thirty red tulips, there must be three of some other color—three surprises, to keep you awake.

Marjolein would deny it if I claimed that she's a flower arranger. And yet she's good at arranging flowers. In spring, most of the vases in the house hold little clutches of tulips or daffodils. They're simple affairs; a celebration of grape

hyacinths for example. Or better yet, she'll tuck one columbine into each of a series of vials; that simple statement grabs your eye. In summer the arrangements become more complex. Just as the prairie becomes a tapestry, the echinacea, bee balm, rattlesnake master, liatris, grasses, sprigs, and twigs are woven into bouquets.

Whatever you do, however you put them together, you can't pick an ugly bunch of flowers. It's always beautiful; there's always balance in it. And you always bring nature into your home. There's the potential for butterflies and bumblebees. I don't need big bouquets, just a few token flowers. No matter how modest, they convey tender feelings of beauty and richness.

Formality (stiffness, she calls it) is never part of the brew—a pure extension of her art, Marjolein's bouquets maintain a sense of spontaneity. No matter how intimate Marjolein has become with the bee balm and the liatris, the bouquets perform no fancy footwork, nothing brazen or cataclysmic. Just unbridled beauty.

Without exception, the bouquets are always specific to the place and the moment. They're about the local vernacular.

Just as she creates gardens around the house as a thoughtful composition that infuses prairie into home turf and merges both into common ground, she brings bouquets indoors. Just as Marjolein flings open windows and doors when she comes home, she puts flowers in the guest room to anchor her visitors in Missouri and its setting. The bouquets are as much a key to understanding Missouri as the prairie itself.

~⅊ . ⅋~

Time Reigns Over Everything

The guest room in the Missouri house is almost an efficiency apartment, with its own bathroom and anteroom. Fresh fruit, nuts, and snacks are always laid out. A few bird books and other books that might pertain are within reach, and Marjolein, the good hostess, always recommends that I avail myself of the food, the bed, and the shower when I first arrive. But really, she's itching to go out on a walk.

First, we go on her usual circuit. We follow the route that she takes every day, unless the weather is absolutely forbidding. Later in the visit, she throws in a little diversity—she might show me the trails by the river, or take the path to the Hallmark Preserve next door. But we start with a broad, leisurely arc around the field, many acres wide. If we set off around four o'clock, we might be back by dinnertime. But we aren't checking our watches.

Time reigns over everything; there's always something to do, some-where to go. Look at this place, it's enchanting. There's something unreal about it—Winnie-the-Pooh and Piglet could come out of the woods at any moment. You've got to give that magic space to happen. You've got to surrender to it. Time spoils every minute.

Surrounding the house is a verge of mown grass rolling down to the pond with a grove of young Heritage birches on the driveway side, planted with plenty of breathing room for each tree at its ultimate maturity. The driveway sweeps up to the house, the mown grass and birch grove on one side; on the other, the natural area that Marjolein and Gaston didn't seed to prairie but set aside, hoping to witness the stages of shrubs and grasses that take hold in Missouri. They know that non-native grasses might impinge, they know that the scrub shrubs will do battle, but they just want to watch it happen. Deep in her heart, Marjolein—the ultimate optimist—is betting that the non-native grasses will lose the battle for turf and that her prairie species will prevail.

No matter which trail you take, the walk always begins on the drive and cuts across a section of mown grass. Because it's open and the grass is short, this is where the killdeers nest.

The killdeers are always swooping around the mown grass beside the prairie. They nest in the clipped grass, but they play over the prairie and pond, darting from point to point with much fanfare, spiking the wind with their high-pitched calls. On the early April evening when we were walking, nests weren't an issue, but family planning was very much in the air.

Just as guys once cruised the boulevards in their convertibles, the birds were doing likewise. The fancy dressers, the goldfinches and bluebirds, were decked out in mating clothes—plumage pulled together with a hot date in mind. But not everyone is given such a dashing outfit to work with. For the killdeers, the emphasis is on real estate. Unstructured though their eventual nest might be, female killdeers go for guys with carpentry skills. The males were busy making test runs, collecting scraps of straw, displaying their credentials as good providers.

Missouri, April 2003

He's pointing out the nest to her, trying to bring her into the mood. A killdeer nest is just a few straws tucked next to a stone. But still, he's trying to impress her.

When Marjolein walks alone, she's in the here-and-now. But she likes to fill me in on the background, so we do a lot of hopping into the future and slipping into the past as we walk the fields. Before I came, she tells me, in very early spring, the purple martins were the first migrants to return to Missouri; the Baltimore oriole also flew in early, but stayed only as a transient. Things that would be in the nothing-to-write-home-about category for most of us are news flashes in Marjolein's journal. When we come up to a certain thicket or knothole, she launches into the story of an opossum encounter or fawn happening with the excitement someone else would display upon meeting a celebrity; and every squirrel is a notable in her book of worthies.

Marjolein fills me in on the ultimate result of the killdeer's talent show. In the end, the killdeers throw together something very shallow and makeshift in the short grass that Woody mows every week. "It's almost not a nest, it's just a few pieces of straw laid in the wrong place." If she manages to find the nest in time, it's flagged with a pole topped by a glove, a signal to Woody that he should veer off and mow around the killdeer's temporary camping site.

Marjolein usually finds the killdeer nests in time to save them from ruin. It isn't much of a feat; killdeers tell you exactly where they're nesting. Come too close to a killdeer nest, and the bird performs an elaborate charade: the female quietly hops some distance away from the nest and then launches into a loud and dramatic series of dances, pretending she's wounded, dragging a wing, and so on. Of course she's leading you away from the nest, and when she's got your attention and you start stalking

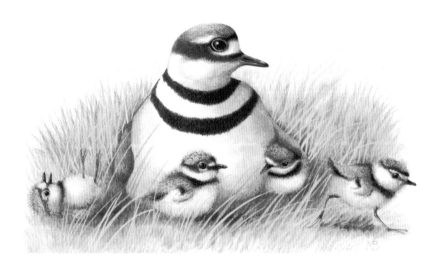

her, she flies off noisily, having succeeded in diverting you from her progeny. It's not an uncommon ploy for ground-nesting species. Upland sandpipers and common nighthawks do the same. Marjolein is no threat, but an opossum or fox might be a problem. Birds that build in the grass need some sort of insurance plan.

In one of Marjolein's many showcases is a piece of broken egg from a killdeer's nest, collected just a few hours after a chick from last year's brood hatched. Constantly surveying the field for signs of action, she watched the hatching through binoculars. Marjolein knew when to begin her surveillance vigil; the killdeer was growing visibly restless.

Missouri, April 2003

The killdeer began looking under her belly, standing up and fidgeting, and looking under her belly again, so I knew that something was going on. And sure enough, a little later, she flew away with a piece of eggshell. A little later, she began looking down and standing up again, flying away with another eggshell. She did this four times, and then, when all four eggs were hatched, two hours later when they were dried, she led them away. It's like a whole movie, right in front of me.

Like ducks, geese, and other shorebirds, killdeers lead their chicks from the nest as soon as they've hatched. So the killdeer ventured forth with her hatchlings—little balls of fluff—crowded under her. She went to seek safety, and to teach the lessons of survival in a landscape that isn't always gentle.

As we round the bend in the trail, a clear view of the Missouri sky opens up ahead. For Marjolein, the sky is always part of the picture—she always scans it for action, monitoring the movement of clouds as much as incoming bird flights. At any given moment the sky will be punctuated by turkey vultures. Earlier, when we were skirting the woods, she observed that a fallen, rotten stump was the sort of place where a vulture might nest. Now she turns her attention to the turkey vultures who have gathered into bands of carousing males but will resume their lonesome vigils later in the season.

Missouri, April 2003

The vultures glide like motorcycle riders on a highway—cruising the skies, senses tuned. They find what has died or been killed using a sense of smell so acute that they can find carrion over a mile away. And the reason that their heads are bare is so they can dig into the carrion without having continually wet head feathers. Hawks and owls kill with their claws, so their feet are more claws than leg. But vultures' food is dead, so they have more foot than claw.

When a vulture glides, the sun catches its underwings, making them shine silver, like a performer in Cirque du Soleil.

The prairie has all sorts of sounds. Sometimes it's like a freight train, sometimes it's a moan or a low drumroll. Today, it allows for easy conversation above its discourse, and as Marjolein points out, you could hear a mouse peep in the thatch if you were attentive. As we walk, she points out her version of marvels on the

sightseeing tour. We stop at the sycamore, still in leaf-bud stage, feel its sticky buds, notice its bark. We note the bugs swarming in frenzies. We see a dragonfly, and Marjolein describes the differences between American species and those from Holland. We listen to the *meep-meep* of a nuthatch; a squirrel crisscrosses our path. It's all acknowledged.

Missouri, April 2003

Look at the bleached field, the way the light hits last year's still-standing straw. It shines with every tassel backlit. Watch how it dances like an ocean; the wave movement of the prairie. Everything has a different texture in the weave. Listen. It's not only the birds. The grasses make such a mighty sound, their stems kicking each other. You could make a symphony of all this music.

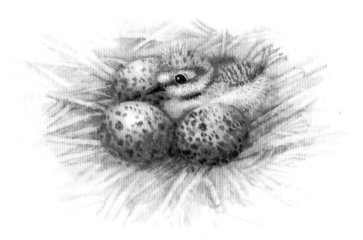

More than anything, Marjolein wants to be part of the symphony that is the prairie. She wants to be a neighbor to all the creatures without altering their lives, so she can watch their comings and goings. An owl acknowledges her, a deer crosses her path, stops, sees her, and resumes whatever it's doing. She doesn't talk to animals; she doesn't try to speak their tongue or communicate. But she wants a relationship. At one point, she shows me a single-file path of matted grass to the river's edge. She's followed it many times.

Missouri, April 2003

The deer have come to use the paths we mow so I can walk the prairie. That's how they travel now. I walk the deer trails, and they walk my trails.

Marjolein has set out salt licks (both mineral salt and plain) and corn for the deer at what she describes as her "four-star eating place." The whole property is set up for the convenience of creatures great and small. For example, the Bastins made a decision not to use weed killers on the lawn because the chemicals might pollute the pond and its wildlife.

The sun is low again when we round the bend in the trail. At that point, the ground swoops into a hollow where a drainage gully has been dug to direct the surging flow of storm runoff during a cloudburst. That's where sixty or more young snakes once emerged from the ditch and crossed Marjolein's path in a slithering herd, headed out to their future homes in the deep grass.

Painted from Memory

From the field, I can see Marjolein come out to the terrace, pace back and forth a few times, binoculars cocked, scanning the field. I've been out there for hours, walking the paths. She might be trying to contact me, she could be worried that I've lost my way in the tall stubble or turned my ankle in a gully, so I do a few jumping jacks to get her attention. But I'm dwarfed by last year's straw.

She wasn't looking for me. I should have guessed; she was keeping tabs on the lone pied-billed grebe that suddenly appeared, mateless, in the pond and has settled in comfortably despite the apparent lack of family prospects. But when I come up to the house, she's raring to go—binoculars have been selected, a fanny pack is around her waist, muck boots poised on standby, she's putting on the scarf that she wears around her neck and pulls up over her face when the sun gets high, and sunscreen is applied. We're ready to walk.

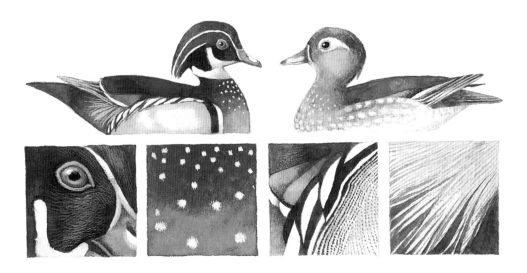

No matter where she is, Marjolein can describe in precise detail the goldfinch that frequents her bird feeder in Missouri: coloration, personality traits, mannerisms, and the way the light falls on its feathers. And those precise descriptions aren't limited to what she saw yesterday, or last week, or last month. Ask her about the ducks around the pond that she visited as a child in Holland, and she can bring back the scene. Often I have a question about a butterfly or bird that we encountered weeks before, and she might ask for more specifics about the scene, but then she'll say, "Okay, I see what you're talking about, I'm there again." And she means it.

I've never seen Marjolein take photographs of anything for reference purposes. In fact, she insists that photographs are more a hindrance than a help, and I've heard other artists make similar statements.

Missouri, April 2003

A photograph is not the trigger that sets me burning. I think of the moment when everything is on fire, when everything is set in action—that's the picture that I want to capture.

Rather than documenting images on film, she works primarily from memory. Although she consults field guides to corroborate her details, most of her work is rendered from what is held in her mind's eye.

I don't have a well-developed memory; I can't always remember Latin names. But my need, my necessity, to have these scenes firm in my mind allows me to bring them back to life. When you love something so much, you can call it back.

What Marjolein strives to capture is movement in nature. And so she remembers a clause rather than a single word. When she draws the robin wrestling with a worm, the action seems to jump off the page. It's a gift that she has, but she sees it as a mission of sorts.

I do the same thing with my clump of memories that a potter does with a lump of clay. I saw the meadowlark, I saw the yellow butterflies, and I can build something from that image without seeing it again. There's a spark that burns it into your memory because you care.

People call it a photographic memory, but that's wrong. It's something so living, it's moving in my mind.

By now, the sun is becoming intense. Three and half years ago, Marjolein developed an allergy to the sun. Fortunately, with time and precautions, the symptoms have subsided to slight swelling and blistering. Still, Marjolein takes care when she goes out.

Like a bandit, Marjolein pulls up her scarf as we cross the mowed area, but then drops it so she can narrate our journey. She can't help herself. She's bursting to share, like a child bubbling over with the latest exciting discovery.

Sometimes we walk in silence, so we can soak it in. Sometimes she gives a running chronicle of what she's perceiving. In spring, there's plenty to report.

Missouri, April 2003

Months ago, nothing was here. Now it's a rich, noisy patchwork of grass blades, and it's easy to forget that last season it was barren. Suddenly your senses are saturated.

The prairie is polka-dotted in spring. Because of the smell of baked soil and decomposition, because everything is heating up, because of the birdsongs. There's a language developing now between the flowers and the grasses; they're developing a dialogue. The whole orchestra is tuning up here. It's in the air that it's spring and no other season.

Even though the sun is rising high, Marjolein doesn't quicken her step or scurry into the shade like the field mice at our feet. If there's a repeated chorus to her song, it's a plea for a slower pace. If only she could achieve that—if only she

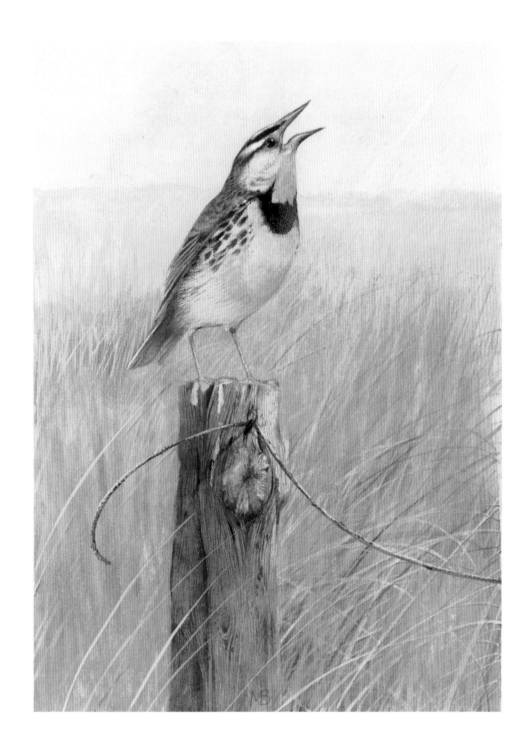

could convince us to slow down as we walk this world—she feels certain that she could also teach us to see, feel, and smell. She has no use for jogging, and says so: "You chase away and don't even see what you've chased away." If everyone would just creep along while walking the fields, surveying the scene, giving it space to happen, they would also welcome back the mourning cloaks of spring, the first butterflies to come out. If others consciously slowed their step, they would notice the antics of the red admirals and painted ladies, they would know that the

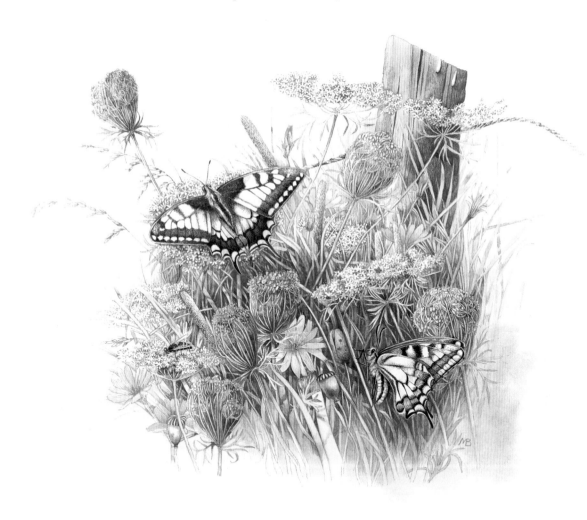

goldfinches swoop low as they fly, like yellow streaking garlands above the prairie. They would hear the deer coming as they break twigs in the woods.

As we near the edge of the wooded area by the lagoon, we pause frequently while Marjolein points out the fox burrow ("I know that a fox lives there because of the size of the entrance, and because a fox burrow doesn't go straight down"), contemplates a stump, or looks for the hollows in the trees where starlings have appropriated squirrel holes. We follow a few paths into the denser trees; she points to where the grass was matted by a muskrat.

Missouri, April 2003

They know all the hideout places. They have a goal and that is to survive. They know where to go if there's danger.

This is where the muskrat lives. Once he came out and didn't even notice that I was there. He woke up, washed himself, and ruffled his fur. He takes pleasure only in the day and the sun, he needs nothing more.

That's how you grow into nature—you think like a muskrat.

We look at droppings. Marjolein loves to contemplate the leavings of the wildlife in her prairie. It gives her an insight into their private worlds. At the least, it's a telling indicator of how they dined.

Missouri, April 2003

You can read the droppings, it puts on another layer. You can tell what the raccoon ate last night—maybe you'll see the hair of a rabbit, maybe the remains of berries, or a small frog or crayfish. You can read it like a story.

There's nothing as interesting as reading an owl pellet. There might be the indigestible parts of mice. Sometimes Gaston brings me pellets as a gift. He knows, after thirty-five years, that a pellet can be my treasure.

The short grass along the mown trail also has a story, and it is the telltale progression of spring. That's where the ranunculus grows in dense colonies, where you could find a dogtooth violet and a phlox. Marjolein stands transfixed by a simple little grouping of phlox, violets, and ground ivy along the path, a combination of spring splendors; it delights her no end.

Smell the ground ivy—the pungence. For me, it's the essence of childhood. It means spring to me.

It's like opening a drawer; you find so many things, so many feelings. Time has no boundaries in spring. You slip back and forth from your childhood.

Marjolein often says that she's too playful to be a "real" naturalist. The scientists would be appalled at her personifications, she often worries. But then again, she has an equally strong message. When we're together in the woods or in the prairie, I'm the one who always wants to hear names. I want to know what this butterfly is called and what that dragonfly is named. If she knows the English designation for that insect, Marjolein politely informs me. But that's not really what she's about.

You shouldn't stop at labeling. The responsibility of mankind is to make the translation from nature to something deep in your heart. It's not about the name. That connection deep in our heart is our song—like a birdsong. It should be our song, anyway.

We sit down and stay there for a while, propped against a fallen tree. Sometimes we talk; more often we are silent. We watch the blues as they flit in the

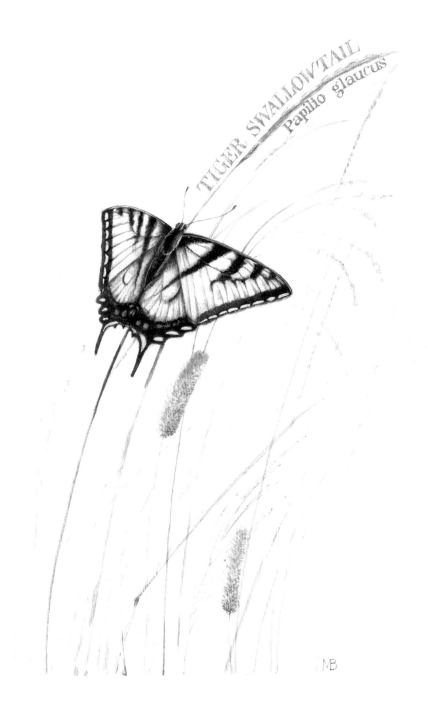

TIGER SWALLOWTAIL

Papilio glaucus

MB

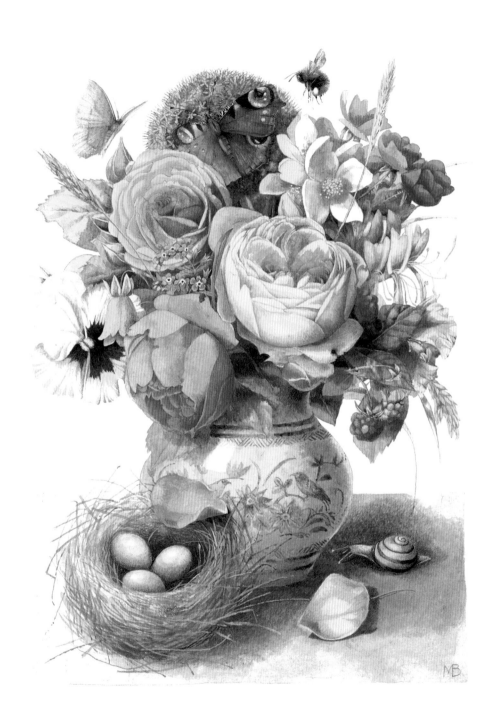

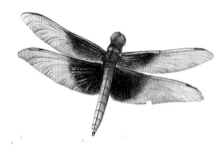

air. We talk about the shade, how good it feels. We explore the flora at eye level, we look above our heads and down at our feet. We contemplate the life hosted by a wild cherry.

Missouri, April 2003

Isn't it strange that you can live with something, and it becomes so familiar? The secret lies in constantly remaining aware of its presence. And then every season of the year makes it richer. You take every experience and glue it on top of the one before.

Every once in a while, Marjolein trains her binoculars on a bird in the distance and patiently waits until I also manage to locate it with mine. She promises that the binoculars will become like second eyes. Someday maybe they will: I'm working on it.

At last one of us remembers to look at her watch, and we realize that lunchtime has long passed. So we begin our slow progress to the coolness of the house and a meal of salad and cheese.

Much later: After Marjolein disappears into her studio and I transcribe my scribbles; after we sit and joke like two schoolgirls in the kitchen and leaf through Marjolein's albums from her college years; after we take our evening walk, I wander into Marjolein's studio to fetch a book to bring to bed with me. There on her desk is a drawing of the phlox, violets, and ground ivy, exactly as we saw it, painted from memory.

The Bird Feeder

Most of the time, Marjolein is working or walking. And the walking part of her schedule is as essential to maintaining the flow of rhythm at the worktable as mixing watercolors or doing rough drafts. But there are times when walking isn't possible, because the prairie is being drenched with either rain or sun. For those times, she has her bird feeder. In a way, she shares the solitude of her work only with the visitors to the feeder. Only they are allowed (and encouraged) to interrupt on a regular basis.

Missouri, April 2003

I can't say what is my favorite bird. I have no favorites. Of course, if you were to ask which bird I would like to be if I were to die and come back as a bird, I could choose a bird to be—it would be a winter wren. But I can't choose favorites among my friends.

They all have virtues. The cowbird, for example, looks very dull in his boring black suit. But when you hear a cowbird sing, it's like gurgling. It's like water tripping over the stones in a brook. From his looks, you wouldn't notice him. But his song is so beautiful. There are so many birds that don't look exciting, or they are soft in color. And they are often dismissed.

In Marjolein's book, supposed negative traits are all part of the natural order. So she doesn't find fault with the fact that cowbirds habitually lay their eggs in the nests of other birds, abandoning the eggs to the care of a surrogate mother. She doesn't criticize cowbird hatchlings for pushing out the other, smaller chicks. And then there's the theory that cowbirds evolved to follow the bison in the prairies, and therefore had no time for the constraints of nest-rearing. That alone would rationalize the cowbird's actions in Marjolein's eyes.

And when I speak of Marjolein's bird feeders, I don't mean a feeder or two, gingerly placed outside and stocked with a token offering of birdseed. What Marjolein has set up is a feathered feast loaded into ten or more stations of different descriptions, carefully concocted to suit every taste.

In both Missouri and Holland, the Bastins have set up surveillance cameras to monitor the feeders, to make absolutely certain that they're always full, and they keep tabs on the action no matter where in the world they happen to be. Marjolein is well aware that this isn't exactly what you'd call normal behavior; no one else

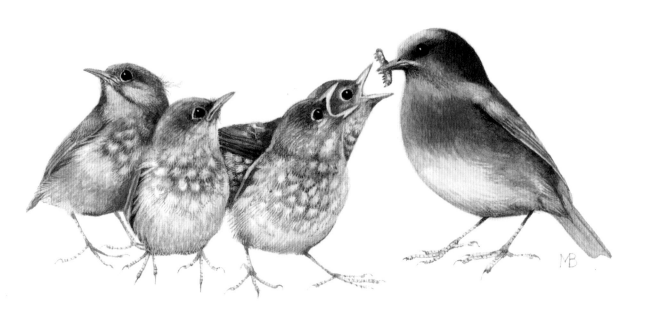

she knows spends spare time eavesdropping on their bird feeders. For that matter, not many people listen to bird CDs for background music. But that's what Marjolein does for recreation. That's how she finds her balance; that's how she tracks the seasons.

Missouri, April 2003

Spring is made up of a series of moments. Spring is a collage of instances when you see the first hummingbird, the first purple martin, or the first flash of a bluebird. It's like getting back something that was taken away from you. And it becomes more valuable because you were deprived of it.

I grew up during the war years when life was very austere. And knowing that we might not have as many toys as we once enjoyed, my mother hid some of our toys and then took them out a few at a time. Winter is like that cupboard where the toys are hidden. Then the treasures come back—the stream rushes, the grass smells, the bluebird flies in. And all those things have a new meaning.

Each bird is nourished in its own way at the feeder: most pause and partake, consuming what they can while sitting at the rest stop, but some prefer to sup alone. That is the mode for the black-capped chickadees who are lured in from the woods to sample the spread. They daintily steal one sunflower seed at a time to

take back to the trees and gnaw in peace. Each bird has certain mannerisms. Even Marjolein has to admit that the house sparrows raise a lot of dust, so to speak, when they fly in. "They come in, hip-hopping around, and they take over," is her observation. The junco, on the other hand, is shy as a rule: "They behave the same way as they look—like porcelain. They have a delicacy to them. And juncos have modest plumage, they're always in the background." Although they wouldn't normally all be at close proximity, they've learned to coexist at the feeder. Sometimes it's harmony. But then in comes a blue jay, and everything is bedlam.

Marjolein doesn't like to make generalities: "There is no simple way of translating the richness in a few brief lines." The point is that bedlam is as much the norm at the feeder as quiet rapport. The goldfinches can be lunching soberly, even in a crowd of sixty or more, and then the arrival of a woodpecker will set the whole bunch on edge. And blue jays and woodpeckers come in constantly.

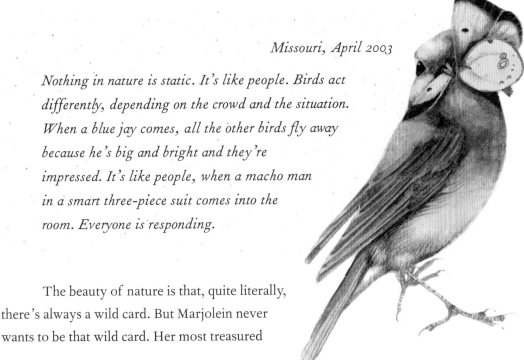

Missouri, April 2003

Nothing in nature is static. It's like people. Birds act differently, depending on the crowd and the situation. When a blue jay comes, all the other birds fly away because he's big and bright and they're impressed. It's like people, when a macho man in a smart three-piece suit comes into the room. Everyone is responding.

The beauty of nature is that, quite literally, there's always a wild card. But Marjolein never wants to be that wild card. Her most treasured

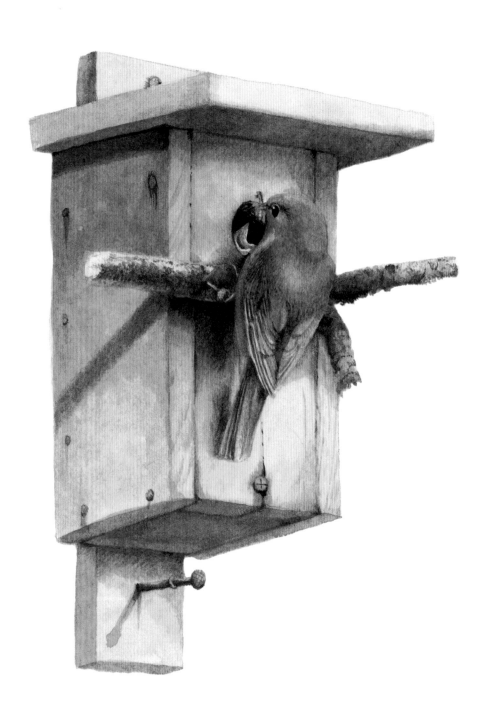

moments come when she's been accepted into the crowd. When creatures—
either furred or feathered—don't see her as a threat, she's on cloud
nine. But even more, she likes to merge into the scene, so that the
boundaries between humanity and the rest of creation are
blurred. She has the ability to lose herself in what she sees.
Why can't it work the other way around? It seems
as though her bird-feeder voyeurism comes from
a wish to be part of the community, part of the
feathered crowd. Nothing thrills Marjolein more
than acceptance into the family of wildlife.

Missouri, April 2003

> *I feel with them. It might be a bird or a squirrel or a spider: when I*
> *become immersed in their world, when I study how they behave,*
> *I become part of their lives. But then again, I also know that I'm*
> *different. I'll always be a human being with shoes on.*

I've never heard Marjolein try to imitate a bird call, except to help me
identify and untangle a single song from the chorus. She doesn't do anything
specific to gain acceptance: she's just a constant presence, that's all. She has shoes
on. But she walks very softly.

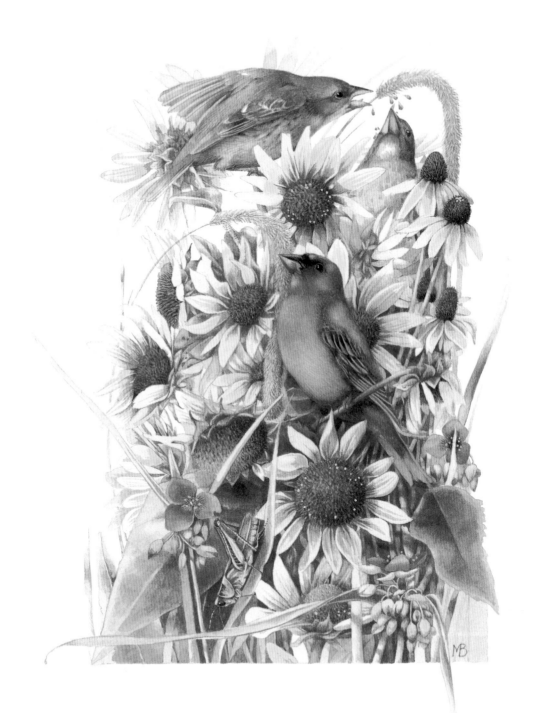

Summer

Holland: The House

There is something magical about arriving at Marjolein's house in Holland. She often talked about "living in the forest" in Holland, and for at least a block before you come to Marjolein's driveway, you get a quick panoramic preview of the forest that's part of the property. So there's a hint of upcoming events even before turning into the drive that travels dart-straight through a long avenue, lined with Douglas firs and rhododendrons. You feel as if you're headed straight for the proverbial little cottage in the woods, complete with mystique and fables—everything seems in suspended animation, trolls could easily

be part of the scene, it could be the stage set for a fairy tale, anything is within the realm of possibility.

Fourteen years ago, the Bastins moved to their current home in the agricultural region outside of Ede, a small town in the eastern region of Holland. Their current house is situated in a scenic area with plenty of Dutch belted (Lakenvelder) cattle grazing in the fields not far away.

Marjolein worked with a landscape designer to create an ingenious spread surrounding the house, the broadest possible configuration of diverse habitats, moods, and stimuli. The scope is boggling, beginning with the wisteria arbor slung loosely over the front door, moving to the carefully clipped parterres in front, and then traveling a few steps past the topiary allée and topiary checkerboard to the pond in back, with its rough-hewn edges and ragged border of marsh plants.

Holland, June 2003

When I close my eyes, I see the wisteria that I had as a child, and so it's the first thing that touches me when I come home. When I close my eyes, I see it, that same pale lavender. When I close my eyes I catch a whiff of its light herbal scent. On every house that I've ever lived in, the first thing that we always plant is wisteria.

I'm always searching for those childhood memories, while making new memories in the meantime.

Built in the 1930s, the house is a low-slung affair composed of several wings to allow Marjolein and Gaston to avoid disturbing each other while at work. Like all of Marjolein's houses, it's mostly windows—floor to ceiling—looking

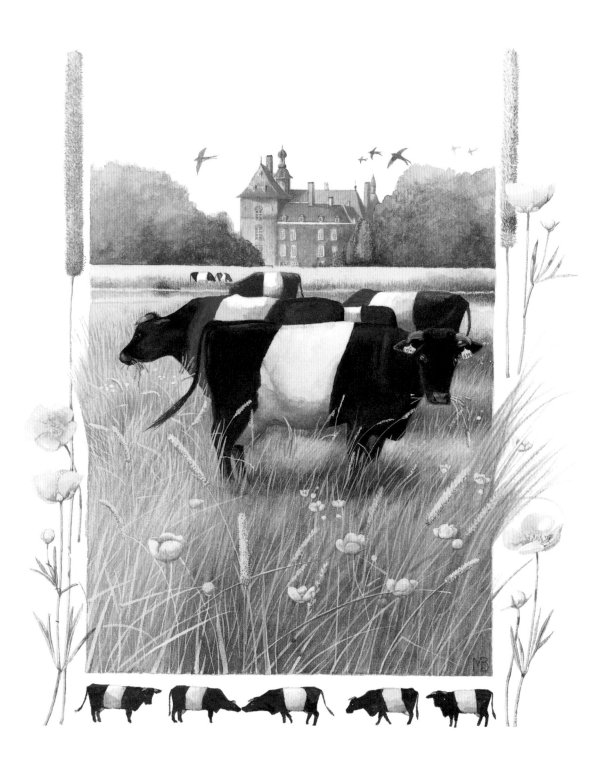

outward from large, airy rooms. The house isn't particularly Dutch: but the thing that makes it fit snugly into its habitat—the feature that is indicative of the local vernacular and wouldn't be found in, say, Switzerland or Colorado—is the thatched roof.

Four years ago Marjolein and Gaston made the decision to thatch their roof, which isn't as revolutionary as it might sound; there are many straw roofs in the vicinity. Invariably practical, Gaston researched the topic in depth and found that, amazingly enough, properly installed thatched roofs last thirty years or more—sometimes fifty years, under good conditions. But, as with everything in Marjolein's life, other factors had to be weighed.

Holland, June 2003

Bats lived in the roof, and we couldn't turn them out of their home. So we requested that there should be an escape route installed for the bats. When we invite guests to come for dinner, not everyone is amused by the vision of forty or sixty bats funneling out from the roof at a certain hour of darkness every evening. But they eat a lot of insects.

The thatched roof is traditionally Dutch, and the parterres are also typical. The Dutch people fell in love with clipped hedges centuries back, and have remained steadfastly loyal to that style of gardening ever since. Just to the left of the wisteria-draped front door, a miniature maze is delineated by compact boxwoods edging beds of sedum or lavender, accented in the center with a bull's-eye of white roses clipped into standard tree form. It's very lovely, very formal, and razor-sharp in its angles—so much so that the tight paths flummox

attempts by rabbits to navigate its convoluted turns and wreak damage.

Turn around and you see the torso of a nude statue against a backdrop of clipped evergreens. Walk through the arbor of 'Seagull' roses to a parklike lawn. Moss-covered brick steps lead to a long allée lined on either side by umpteen strictly pruned boxwood orbs planted two deep in military-straight rows, as if in formation for inspection. Those topiary troops are, in turn, backed by a much taller row of clipped conical yews, framing your view and directing it to the focal points at either end. At the house end there's a seating area for dinner on a brick patio with an arched, Monet-style, rose-embowered arbor framing the view. Marjolein likes to counterpoint shapes one against the other, and she's definitely not immune to the romance of a rose arbor. But her attempts to host roses have been continually thwarted—with the exception of 'Seagull', which seems blissfully content. The far end of the allée is punctuated by a very Lutyens-style bench.

That's not the end of the topiary: outside her office windows, Marjolein has orchestrated a checkerboard of shorn boxwood orbs of different heights and widths, nestled together like a crowd of people of diverse shape and heft. There's a pair of double-decker orbs thrown in for diversity, some cones and pyramids sprinkled here and there; there might be two dozen or more of these fanciful creations, each a work of art in its own right. I've never seen anything quite like it. Neither had Marjolein, I bet, but somehow she envisioned it. And now it stands as a living sculpture, always in flux but carefully maintained.

It has to do with form and light and shade, it's like waves. It's architecture, and it's fun that you can shape everything.

Just to fine-tune the presentation and leave no doubt as to whether the effect is meant to be serious or madcap, Marjolein has lined up a series of lead statues—all identical and perfectly spaced—depicting her nemesis, the rabbit. They're just the beginning of the rabbit statues, which appear throughout the garden nearly as frequently as birdhouses.

Even that isn't the final tip to topiary. The view toward the pond is framed by a chorus line of tall, lollipop-trained catalpas; a set of four holly standards act as sentinels around the birdbath, providing berries for thrushes and blackbirds. And the herb garden farther afield is also defined by clipped boxwood parterres punctuated by a boxwood peacock for a focal point. As Marjolein often says, the topiary keeps the garden in line. And it also imposes an order that is sacred to Marjolein's practical Dutch side. On June 21, the solstice, the hedges are pruned.

In my garden there's the topiary hedges. That's Gaston to me. He anchors my garden, just like the hedges. He's my backbone. He makes it possible for me to flower and bloom and fly and make mistakes. I can do it all, but only with his protection. The topiary makes the garden possible.

Despite its immaculate impression, the garden isn't particularly high maintenance. The grass is cut weekly. The gardener (Dino, Marjolein's son-in-law) waters the many potted plants on the patios, removes weeds from among the astilbe, grapples with the heather beetle that strips the plants (but is tolerated by Marjolein because heather is its primary host plant), and otherwise performs general upkeep. But control and order stops when you pass a certain point. Behind the house is a pond, left to grow wild.

Holland, June 2003

I live here, and nature is there, and we would like to melt together.

Nesting Boxes

Before my first visit, Marjolein made a few phone calls to inquire about my eating habits. We got very specific: she wanted to know exactly what to have on hand; whether I liked yogurt, for example, and which brand. Needless to say, her hospitality extends to birds. Although I know all manner of bird fanciers, I can honestly say that I've never seen such a profusion of nesting boxes (which is Marjolein's way of saying "birdhouses") as I came across at the Bastins' Dutch home. Immediately around the house, every tree that could support a nesting box was fitted with one or two. None of these were fancy. I didn't find a single birdhouse that looked like a church, cathedral, farmhouse, or any other manmade piece of architecture. They were all totally utilitarian, designed for the purpose of laying eggs.

For that laudable pastime, Marjolein has found the perfect box: cement and wood, with rounded walls and a sliding front panel for easy cleaning. However, there are many variations on that basic design. Because, as Marjolein explained, every bird has its own set of qualifications for a dream house.

Holland, June 2003

Each nesting box is designed for a specific bird, with just the right front door opening or the ideal type of entry. And they never respond to it. Never.

Instead, I see nuthatches working like crazy, bringing beak load after beak load of clay to close up that hole and make a nesting box meant for a much larger bird right for their purposes. Birds just like to renovate.

But the fact that the birds insist on rebuilding to suit in no way stops Marjolein from trying to spare them the trouble. As we walked through the woods, she explained the reasoning behind every nesting box design on the property. Clearly, it's a science—an unappreciated science, but a science nonetheless.

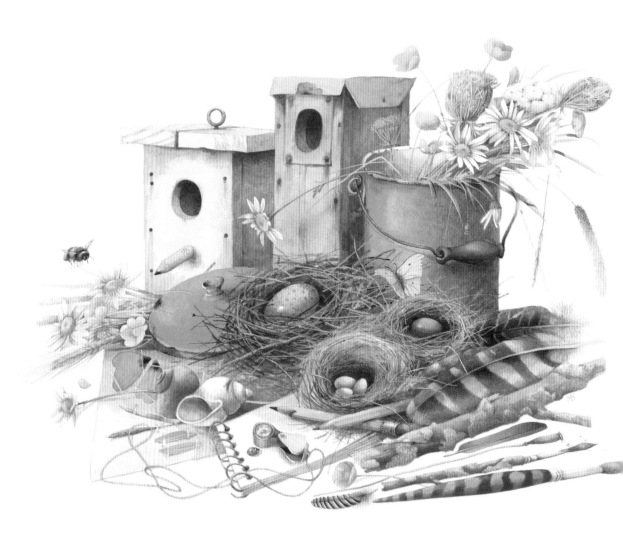

*The nuthatch house has a tunnel entryway in the front door—
because, theoretically, they like to enter a cavity—although they
seem to prefer to perform the craftsmanship themselves. The blue
tit boxes have a small entrance where only they can come in, but
the larger coal tit can't squeeze through. The coal tits like to nest
closer to the ground, so we position their houses lower. Owls like to
be high up in the tree. The treecreeper has a side entrance to his
house so he can creep in from the tree trunk rather than flying in.
The starling (and starlings are rare in my garden in Holland)
need a larger entrance. Flycatchers like to perform at the front
door, so they have an elongated entrance. And the wagtail, she
likes an open porch.*

She does her best, and the birds respond or not, depending upon their
mood. As far as Marjolein is concerned, whatever happens is fine. And she's also
not disheartened by those who ignore her open invitation. As we walked through
the woods, Marjolein explained which trees were most apt to be pressed into
service by woodpeckers and the like—beeches and rotten apple trees are prime
real estate for birds that want to carve their own holes. The Douglas fir, on the
other hand, is almost never chosen—its bark contains too much tar pitch to serve
as a convenient construction site. But not everyone is interested in building. Owls
are above doing the carpentry necessary to create their own hole. Instead, they
requisition a rotten cavity in an old tree, or take a second mortgage on a
woodpecker hole. Their nests, in turn, are recycled by stock doves.

And there are always those who must make a nuisance of themselves, no matter what sort of accommodations are offered. Great tits persist in nesting in mailboxes. "And then you have to hang a note on the box, informing the postman that he can't deliver until the family has fledged." The architectural preferences of birds interest Marjolein, but she finds nest-building even more fascinating.

Holland, June 2003

I once saw a European starling weave bright pink and yellow flowers into her nest—like wallpapering her bedroom. Long-tailed tits make the most beautiful nests. They build closed oval nests right about eye-level in evergreens, and you can often see a long tail poking out of the nest. Inside, they're lined with feathers, and outside, they're camouflaged with bark and lichen and held together with spider webs. Once I counted three hundred feathers in a single nest.

Birds of a Feather

Marjolein views the antics of baby birds with bemusement: even a critical note creeps in when she speaks of their sometimes clumsy and certainly unpredictable behavior. She knows just how a dunnock should be acting, and when a dunnock deviates markedly, she'll dismiss the action, saying, "That's a baby bird."

She looks askance at a newly fledged sparrow's bizarre, death-defying acrobatics and failed attempts to snag an oversize dragonfly. When a bird flies pellmell into the window without watching where it's going and then repeats the same dumb mistake minutes later, she mutters, "It's a fledgling." Any rule you make about bird behavior, fledglings will break. Which is probably one reason why baby birds so often appear in her drawings. There's nothing Marjolein applauds more vigorously than individuality.

A whole lot of fledging was going on when I was in Holland. Even with the abundance of youngsters, Marjolein could tell me a tidbit or two about any given bird's adult behavior; his quirks and countenance. Once I asked Gaston if he was familiar with birds, and he admitted to being able to identify most of them. "I couldn't help but learn them," he said; "it rubs off."

America shares some birds in common with Holland. We both have winter wrens, starlings, barn swallows, and house sparrows. But there were many new acquaintances as well. The European robin had me confused at first. Marjolein kept talking about the robin, and I kept asking, "Where?" Turned out he's a totally different bird from the American robin; much smaller, but also with a rouge chest and a rather self-assertive manner. "He's a loner." According to Marjolein, the European robin is the last bird to sing in

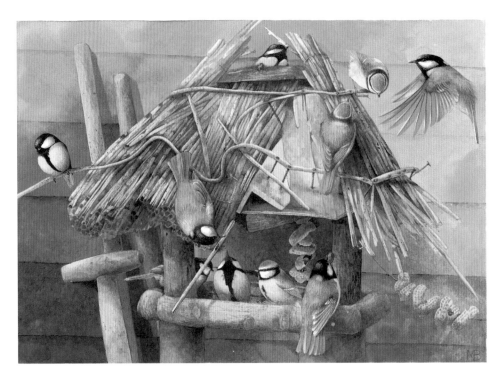

the evening in her garden, having better night vision than other birds. He's not upstaged by the nightingale, who serenades some other regions of Holland.

One evening we watched as the cocky little European robin flitted from perch to perch, declaring his territory and leaving a trophy splat on each and every stump and log that he lighted upon. "That means he's very proud of himself," Marjolein assured us.

<div align="right">

Holland, June 2003

</div>

The blackbird and song thrush, they're the first birds to sing at dawn.
For me, it's always a relief to hear the first birdsong of the morning.

I can't imagine Marjolein in a room without windows. I'm not sure she would long survive without the frequent opportunity to commune with birds flitting outdoors. Even after we returned to her studio from a long walk outdoors, she was still all eyes and ears; she couldn't pull herself away from her communion with the birds. So our conversation was always peppered with comments like, "That's the dunnock. Oh, she's a real hooker—she's always willing and waiting."

The tits were an ongoing joke between us. She'd warned, even before I arrived, that they had great tits in Holland. And there was much snickering when she could proudly point out the flock of great tits and blue tits as they fluttered with their traveling companions, the nuthatches, in the trees.

They're small birds, and they're ingenious—the coal tits line their nests with cattail down when the opportunity arises. The great tit uses moss and hair for his construction materials, as well as adding versatility to his attributes. "He has the most variety of calls. They're not songs, really, but complex calls repeated often with a few nice tones introduced in."

Holland, June 2003

The great tit has a strong presence. His body language is ferocious, as if to say, "This is my slice of bread."

Of all the tits, the blue tit dominated in Marjolein's backyard. Small and fierce, he and his companions reminded us of a circus act. The blue tits who hang upside down on thin twigs are tightrope walkers. And their fledglings, well, needless to say—they're clowns.

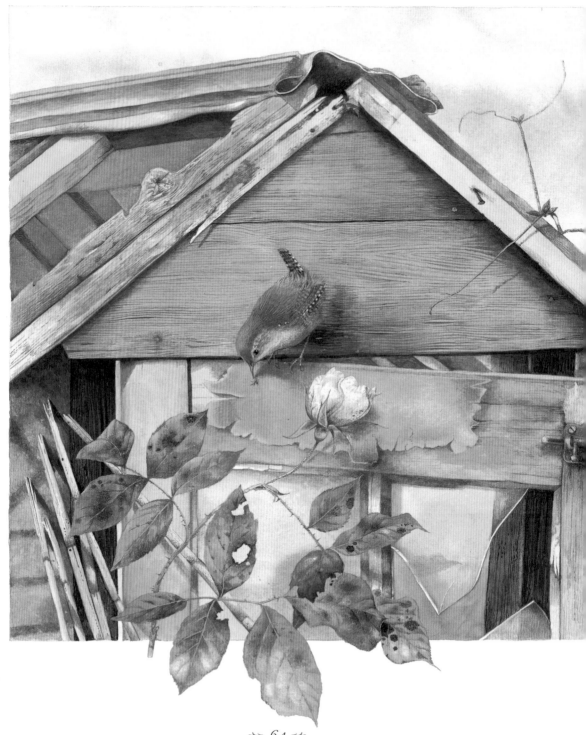

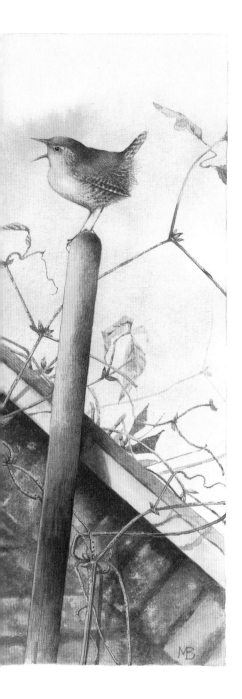

The Herb Garden

Marjolein isn't really a creature of habit, but more often than not her evening walks in Holland lead to her herb garden. When I was there, I came along.

If you summon all your fantasies about finding forgotten gardens lost in the tangle of a turn in the woods, you can imagine how it feels to come upon Marjolein's herb garden at dusk.

Tucked out of view of the house, it is only reached after rounding a bend and wading through the tall grass of the orchard. From the woods in the other direction, it's hidden behind a wall and gate. In that sense, it has always retained the original quality of mystery that flavored Marjolein and Gaston's first brush with the lost and found garden.

One afternoon Marjolein and I were sitting shoulder to shoulder, shuffling through a shoe box filled with a confusion of old photos. We found a few snapshots of the original herb garden, predating the Bastins' residence. When they first began the restoration, it had a ghostly presence. That's the only way that I can describe it, because there was as much barrenness then as there is lushness now.

We knew it was a garden, but when we came, it was a wild and wooded place. One day we found a buried brick and another brick, and when we began to dig, we found a pattern. So we pieced them together and rebuilt the walkways of the garden using those old bricks.

But Marjolein saw the potential. Perhaps it was the mystique; perhaps she saw a place that desperately needed her affection. For Marjolein, the herb garden has always had a special magnetism. Now, given over to herbs and incidentals, spilling with *Campanula lactiflora* and rue as well as lovage, chives, and parsley, it has lost all ties to necessity. Or to reality. In that sense, Marjolein re-created the garden of her childhood, a place of essentially traditional elements but with no fixed point in time; a place of narrow old brick walkways, of whimsical topiary, suffused with blossoms, color, and scents.

In a sense, the herb garden, with its low-clipped, boxwood-edged parterres, sundial, and beds filled with aromatic herbs, bears witness to a gardener who was both sensitive and receptive at a very young age. When Marjolein returns to America every year, I think it's the herb garden that she misses most.

Holland, June 2003

We built a wall around our herb garden because I wanted to wall myself out of time. There is a sundial, but there should be no time in here.

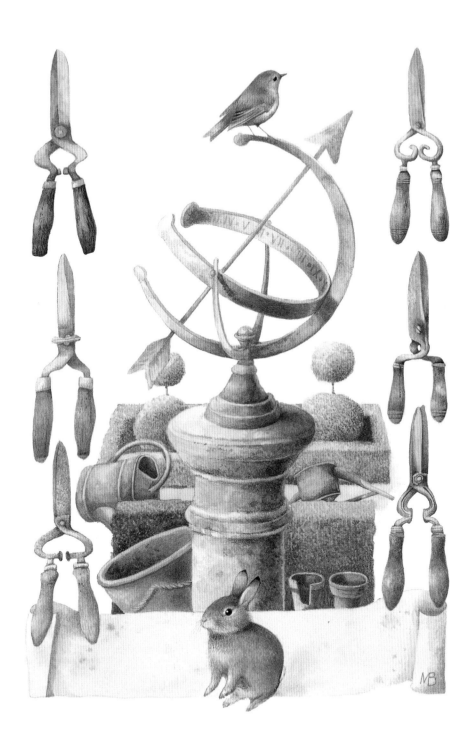

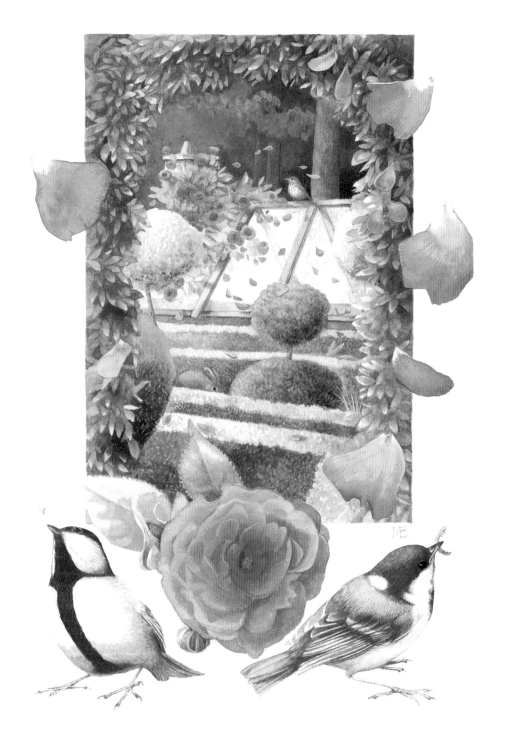

The back and sides of the garden are sealed off by a brick wall. Along the front, facing the orchard, the line of demarcation is nothing more than a hedge of closely clipped beeches. The hedge was installed while the beeches were dormant, and one of them turned out to be copper in color, much to Marjolein's delight—nothing she loves more than a happy accident. Inside the hedge, a series of square, boxwood-edged beds are filled with the predictable thyme, lovage, and marjoram that should dwell in any herb garden. (Marjoram was a must; Marjolein was named for that herb.) The place isn't confined to herbs: it also hosts flowers that tug memory strings, such as lychnis, a flower that we know as rose campion and the Dutch call "prickly noses."

Holland, June 2003

Those were the flowers my father gave us from my mother's garden. And when he teased us and coaxed us to smell the flowers, they tickled.

With typical Bastin tongue-in-cheek, the accent in the garden is a peacock topiary that might look more like a squirrel, depending upon who's done the shearing. And there's the sundial that reminds you to forget time. But the outstanding feature in the garden is the sunken greenhouse, with its diminutive dimensions and close, warm ambience.

A relic from the past owners, the greenhouse spent some time in a forgotten state but was inherited in working condition. I'm not sure that Gaston can stand straight without stooping in the greenhouse. To enter, you go down a set of steep steps from ground level and slip through one of the narrowest doors you've ever encountered. If the winter wren finds an opportunity, that's where

she'll nest—between the wood ledge and the bricks over that narrow door—making it necessary to leave the door cracked ajar for the rest of the season. Inside, seedlings were once started in the heat of a little wood stove built into a chimney. But it's been a long time since Marjolein could divide her attention between her drawing desk and the duties of maintaining a wood fire. So now the greenhouse is devoted mostly to tools, favorite old watering cans, and irreparably chipped porcelain serving dishes overflowing with seashells, snail shells, and animal skulls.

The greenhouse is the consummate place to hide. Underground and therefore cool, it's shielded from the hot sun by the protective camouflage of vines outside. On one exposure, an aristolochia drapes, shading the glass with a dense cover of heart-shaped leaves. The other slope is dappled with the pink, climbing *Rosa* 'Zéphirine Drouhin,' which dates back to 1868.

Holland, June 2003

When the rose is finished blossoming, when the petals drop, they fall on the greenhouse, like a painting on the glass.

Behind the greenhouse, the garden drops any semblance of a stiff upper lip. There the beds are filled with treasures of all shapes and sizes, tumbling over one another in unfettered exuberance. Some came as gifts; others were whims. Plants that we might call weeds—Joe Pye weed (they call it queen's herb in Dutch), for one—are Marjolein's dearest treasures.

Holland, June 2003

What I like so much is that there are no rules here. I try out to see what works in this garden. It's a playpen of sorts. This is a garden of leftovers. You discover things here; it's a place to see bird's nests.

Like O'Hare Airport at rush hour, the herb garden is serenaded by an underlying buzz of takeoffs and landings as squadrons of wasps, hoverflies, green bottle flies, and bumblebees go about their daily rounds. During my daytime visits the sound of wings was omnipresent, the sense of motion almost dizzying. The more I looked, the more I saw in a world of insects that had always slipped just below or just above my radar screen. She pointed out the multitudes of wasps, each one shimmering in a kaleidoscope of color. We explored the body art and aerodynamics of dragonflies that paused for a minute in their flight. Even the abdomens of the flies sparkled like jewels when we stopped, watched, and looked.

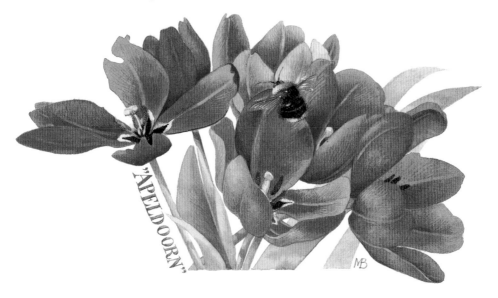

"APELDOORN"

The insects—the working class in this factory—were too absorbed in their daily tasks to bother us. If they became tangled in our hair or climbed up our legs, it was just because we were an obstruction in their flight plan. We were the least of the attractions in this land of aphid milk and bee-balm honey.

The flowers were the stars. Marjolein and I stood enthralled by the costumes and customs of the suitors that flowers attract. There was entertainment going on in the herb garden—the air was filled with music every evening, and it was live.

Holland, June 2003

When I want to hear the sound of summer, I come here. It's like a concert—higher and lower, near and far. I can stand here for ten minutes, just taking it in, seeing what they do, hearing what they do, smelling what attracts them. And always, I feel as if I'm part of this, watching it happen. This is planting and harvesting. You plant something and you wonder, what will it bring for creatures? When you're doing something, it's answered by something in nature—there's always a reaction.

I spend a great deal of time working in gardens. I walk in gardens even more. But never before was I so aware of the throbbing pulse of life around me as I was at dusk in Marjolein's herb garden. On one level, it was a phenomenally big scheme, with lives being lost, territories being defended, births and deaths; but it was all happening in miniature, which only intensified its tension and

impact. Every wand of marjoram blossom hosted a world within this world—a microcosm complete with sex, violence, greed and charity. Anywhere on earth a similar peep show would be unfolding: tickets free.

Holland, June 2003

Look. Look closer. Even the ants we are looking at are milking the aphids for honeydew.

The nice thing about all these discoveries is that it makes you smaller. It's so good to realize that you're part of a much bigger thing. You become lost in it, but also found in it.

Most evenings, it was nearly ten o'clock and the summer light was finally gone when we pulled ourselves from the antics in the herb garden to begin our slow walk home. Marjolein was usually quiet, humming a little, resonating from the flying circus that we'd just watched. But sometimes she told me about the dragonfly she'd watched for two hours as it emerged from its previous instar, pumped with air and fluid, to begin testing its wings. For her, that was the greatest show on earth.

Holland, June 2003

It's something parents should do for their children. It's the food of life. Just like you don't always give children sweets, you give them food that will nourish for the rest of their lives. And no one can take that away from them. They will always have that dragonfly.

Into the Woods

Marjolein's home is surrounded by woods that she very conscientiously does not fuss over. In practical terms, that means she doesn't remove dead or fallen trees that might serve as food for beetles and grubs that, in turn, feed the woodpeckers. This might seem like poor housekeeping, especially for a person who loves to garden. But to Marjolein, who is fastidious inside her home, it's the only way to host nature.

The forest forms a buffer zone around the house, protecting it from the realities of the outer world. The woods help create and reinforce the magical atmosphere that prevails in that place. If it weren't for the woods, Marjolein's home probably wouldn't have that slightly unreal, Brigadoon quality.

The fallen trees and dead wood are deceptive, of course, because the forest is actually well tended. Numerous trails are cut through the woods, and if they weren't meticulously and continually maintained, they would rapidly become overgrown. Every once in a while, a trail intersects a lane lined with Douglas firs, like the driveway that enters from the front gate. Those are the old hunting allées, relics from the early twentieth century when gentlemen came to hunt and had their manservants or dogs scare up the game, sending them running or flying across the allée and allowing a direct shot from the end of the clearing. It's not Marjolein's favorite piece of history, but she maintains the allées nonetheless; they make it easier to eavesdrop.

Eavesdropping in Holland has less to do with squirrels than it would in American woods. The European squirrel, with his little ear tufts, is not as saucy or nearly as omnipresent as the rascal that you can hear taunting some other creature at any given moment somewhere in the United States. There

might be only half a dozen squirrels in Marjolein's woods, and she knows each individual by his coloration or perhaps a unique marking or scar in his fur.

Like North American squirrels, the European version gets into trouble and causes an uproar. A squirrel, for example, was responsible for confiscating the crested tit's eggs. But his misdemeanors are nothing compared to other delinquents. If the woods suddenly bursts into warning cries, the cause more often is a magpie, who habitually steals eggs from other bird's homes.

Holland, June 2003

Those who condemn the magpie's thievery don't understand total nature. If you could see them make love and build nests, you wouldn't say that their young should starve. When I see a robbery happen, I go out and clap my hands to scare the thief off. But even when he's successful, there's always a balance.

There were plenty of nests for the magpie to target. The verge of the woods is dotted with birdhouses, each designed for a specific resident. Activity in those houses was fairly brisk on the June mornings when we walked, as the forest rang with the calls of birds, warning each other off or informing mates of their where-abouts. Every once in a while, Marjolein would annotate our discussion or fill a lull by adding her running translation—"That's the treecreeper; that's the pipit—"

It was all second nature to her, like listening to the squabbling of siblings in your home. And, like a conversation, she could almost predict what the response would be. After the male robin sang, his female would answer. A male would defend his territory, another male would state his challenge. In that way, every forest has its own unique sound, just as every garden has its own perfume.

Here, I recognize every word in the conversation. In Missouri, it was like Chinese at first. When I came there, it was like babbling. Then I began to hear words.

Every once in a while, Marjolein would hear a break in the twigs, and we would stand frozen, hoping that some creature would appear. But as Marjolein pointed out, our progress was hardly quiet as she broke the silence to give a running

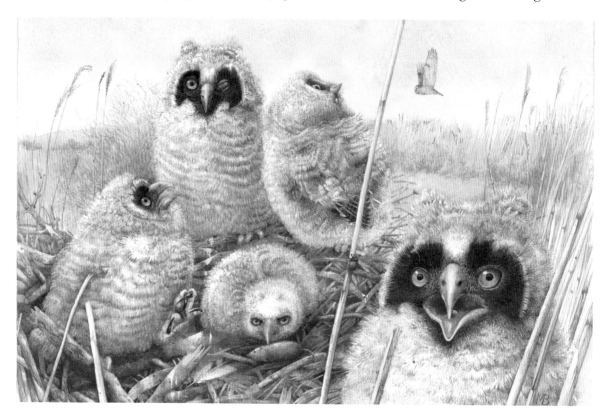

commentary of the journey, explaining the import of nibbled twigs, ruts in the forest floor, and dugouts.

Our first walk when I arrived was the most memorable. It was morning, cool and damp. Holland is often damp, although Marjolein lives in one of the drier regions. We set off early because there's always a certain element of excitement in the early morning. After we'd passed the verge where Marjolein's nesting boxes were hung, we walked deeper into the woods, through dappled, early-morning sunbeams, and passed the more solitary boxes set up specifically for the owls.

Holland, June 2003

For fourteen years, the tawny owl has nested here every year. An owl lays an egg every day and sits on her nest immediately, unlike the great tit, for example, who waits until she has a clutch of many eggs to begin incubating. So an owl's young hatch one by one as they've been laid, and they're of different ages and sizes. The first one that hatches will always be strongest. And when food is scarce, the big brother might eat the smaller sibling.

If you look in the nest, you'll find the fur of a young rabbit, or parts of a song thrush or a mouse. When the owl or the buzzard is near, everyone gives warning to their children to beware.

The owl was nowhere to be seen. And the buzzard was also not apparent on that summer morning, although Marjolein pointed out evidence of his enterprises. She stopped and pondered meaningfully a long white line running across the trail, as if someone had spray-painted a crosswalk in the dirt.

Normally, other birds leave a little splat. But birds of prey poop
while preparing for takeoff, leaving a telltale long line. After all,
they're speedboats.

We followed the path in deeper and farther from the house, finding branches snapped off and nibbled off by deer and noticing the thickets in the woods where does left their fawns unsupervised while the adults went to browse, knowing that the young were camouflaged by speckles. The newborns are difficult to see, instinctively freezing if danger approaches; and, in a world where all senses are applied as survival tools, fawns are virtually scentless and therefore invisible to most predators.

The does and their fawns remain mostly hidden in the woods by day, but a pair of bachelor bucks browse daily in the farther field near the orchard. Much larger than the white-tailed deer that frolic and wreak havoc in American woods, the bucks are a presence to be reckoned with—and admired.

Last night, I went on a walk in the dusk, and found myself
standing in the trail with the big bucks staring at me. I can't tell
you how deeply that moved me. When you look at someone
straight eye to eye, it merges you together. I knew we had a
relationship. And they just stood there, staring at me for a long
time. The three of us, we had a long conversation last night.

If the deer has a foe in Marjolein's woods, it isn't the human residents.
Once Marjolein found half a deer carcass dragged to a fox burrow. She watched
while the kits came out and played with the catch, but she feels certain that the deer
was a secondhand gift and must have been killed on the road. More often, the foxes
that share Marjolein's woods go for smaller prey.

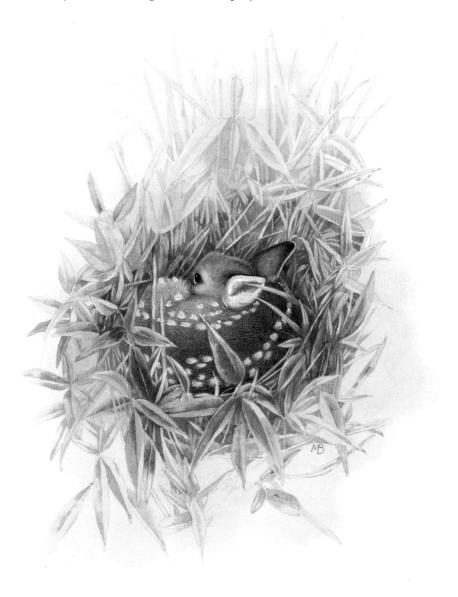

Holland, June 2003

Both the father and mother fox raise the kits in spring. This is paradise
for them, because they catch rabbits—and we have tons of rabbits.
They also catch squirrels and eat dung beetles. I've explored their
droppings and found beetle parts and pieces of mice. And in high
summer, the droppings will be dark purple from the wild blueberries.

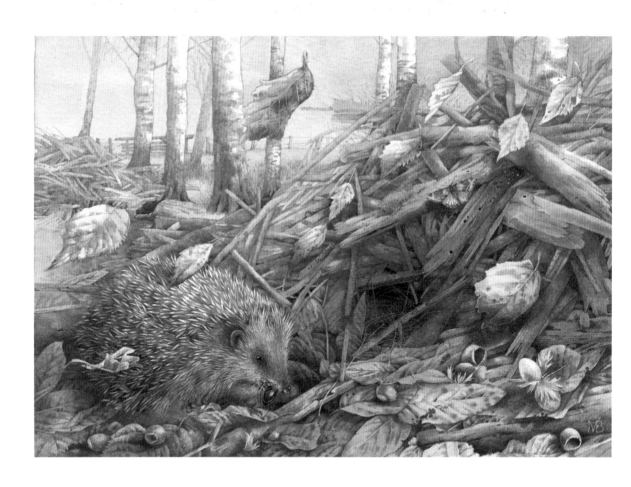

Among the multitude of unseen denizens of the forest are the hedgehogs that hibernate in wood or leaf piles and, even more precious, badgers. Badgers are endangered in Holland, and they command awe in the general population. Needless to say, seeing a badger is the hope and dream of any naturalist. Marjolein prayed for a chance encounter for many years before she took steps to make it happen.

Holland, June 2003

Badgers are very shy. The only traces I've seen are the evidence of their bathrooms in the woods. For centuries, they were chased away because the farmers dislike them. They make huge burrows in the crop fields and then eat the crops. So they were hunted, and now they're very rare.

I wanted to draw the badgers, but I only knew them from pictures. And I must be emotional about a subject before I can draw it. So I was invited by a forester to see them. We sat for hours at dusk waiting at the burrow for the badgers to come out. We waited and waited, Gaston and I, until we began to wonder whether this was such a good idea.

Finally they came out, and the baby badgers were rolling over each other like puppies. That was the first time I saw them, and it made a deep impression. Later, I was invited to an animal hospital that restores wounded badgers to health. Then I could touch them.

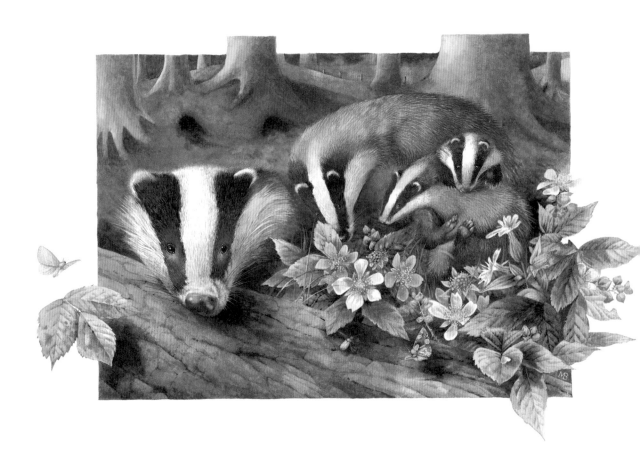

Badger encounters are to be cherished. But Marjolein is more apt to point out the commonalties and daily occurrences typical of Holland than the rare sightings. So we picked up feathers, and we poked at droppings with sticks. We examined wads of fur and theorized on the fate of whomever the fur had belonged to. We spent many hours pondering deer thickets before emerging from the woods to cross back through the pond, over the bridge, and toward the house.

THE DESK IN THE STUDIO

Marjolein's studio is an airy room. It has such a relaxed, warm feeling that it doesn't immediately strike you as a workspace. Marjolein's personality is evident in every nook and cranny of the studio. But even so, it's a fairly straightforward, no-nonsense space without frivolities—with the exception of an antique rocking horse placed in front of the window behind Marjolein's desk.

The desk dominates the room. Predictably, the desk is huge and white—she can't work on any other surface. The desk in Holland is placed where it faces the pond. Without exception, it's always absolutely clean, a fact that I find both enviable and remarkable, considering the bulk of work that comes and goes from its surface. Whatever she happens to be working on is front and center and always within view; she never puts projects away for the evening during their creative process. But then, Marjolein works so late at night and so early in the morning that the desk has no down time.

The desk isn't bare; its surface shows the topography of the job at hand. There are a few feathers and insects laid neatly within view, sometimes because they were just discovered on a walk, more often because they're going to figure into the composition in progress. Her paints are always close by, her plastic palette at hand, and all sorts of pencils and artists pens poised and waiting in a cup nearby. In summer, a modest bouquet is also part of the desk scene. It's very informal, personal, and uncontrived—a composition of sprigs and color. Most often it's a working bouquet, tucked into a glass inkwell or antique perfume bottle, containing whatever flower happens to be featured in the current illustration.

There are other reference tools at hand. If she's working on something in a series, such as a Vera the Mouse drawing, a favorite previous drawing of Vera (or one of Vera's cohorts) will be laid where it will flavor the mood. Even more often, there will be a tiny thumbnail sketch of the drawing's composition in thin pencil scribbled on a scrap of paper with notes written along the margin. Her reading glasses are laid out, and binoculars are also within easy reach. Sometimes there's a nature guide nearby, allowing Marjolein to cross-reference the precise placement of spots on a butterfly's wings, the number of ray petals in a blossom, or some other exact detail. There is no computer.

Stacked up on a side table is a sizable pile of artwork that Marjolein completed while in Holland, wrapped and waiting to go to Missouri. The stack grows as the days flow by, a testimonial to the hours that she has spent drawing. But between the brushstrokes, some of Marjolein's time was spent watching the cameras trained on her bird feeders in Kearney. She can see, but not hear, so when it's time to return to Missouri—when her calendar is booked with interviews, appointments, and commitments in America—she can hardly wait to listen again to the song of the meadowlark as he glides over the tall-grass prairie.

Missouri: Making a Walk

Other people make dinner or make a garden; Marjolein makes walks. "Let's make a walk," she'll say, as if we're creating a tangible object, and it's the solution to every impasse and to all that's wrong in the world. So that was what we did when Marjolein returned to Missouri.

Marjolein sometimes walks out of habit or to be sociable. She walks to study, she walks to find, but she also walks to become lost. "The more you fade away, the better the connection works," she often says.

Missouri, July 2003

Walking at such a slow pace, it's as if you're a field being plowed. Slowly, everything comes up. Walking frees you from being caught between the walls.

It brings everything into perspective. How many times have I been comforted by nature! So many walks have begun with either burdens or pains, and the first aid came from nature. The closer you come, the deeper the cure. Sitting with your back against a tree trunk and buttocks sunk into the grass, you get your balance back.

On the summer morning when we set out from the house, when we "made our walk," I think Marjolein went for refreshment. The heat wave that had wracked Missouri for many days had finally broken, having already taken its toll from everything but the bluestem. And Marjolein seemed to seek equilibrium in it all. She was searching for evidence of survivors; she needed to know that life went

on despite drought, intense heat, and all its attendant hardships. She wanted to feel the strength of the prairie.

As we went out, we looked for nothing in particular and found random bits of sustenance that fit into no subject title whatsoever. But the message that day—the underlying theme of that morning walk—would be about adaptation; I could sense it from the very first steps.

First Marjolein wanted to take me through the section of land that she called "the old pasture." Originally covered with a mantle of grass and clover, the old pasture had not been seeded to the prairie mix when the rest of the acreage was prepared. Instead, it was left unmown and allowed to follow a natural progression, with the Bastins rooting strongly for the dominance of the prairie grasses. They were trying hard not to intervene, but you could tell where their affinities lay. As for Marjolein, she takes that walking route regularly, just to cheer on the home team. If positive vibes have anything to do with it (and you can't convince Marjolein otherwise), then the bluestem will gain supremacy. Already, it's beginning to make its stand.

Missouri, July 2003

I trust the strength of the prairie so much. I believe in the natural balance. The weeds will come in, but the bluestem will win in the end. It takes a long time. You have to wait for the balance.

Marjolein never preaches as we walk through the prairie. She talks about what we see and how she feels, but she doesn't pass judgment. Still, she took me through the old pasture that morning as a prelude; the first parable along the subtle survival theme that day. The old pasture demonstrated the strength of natural selection.

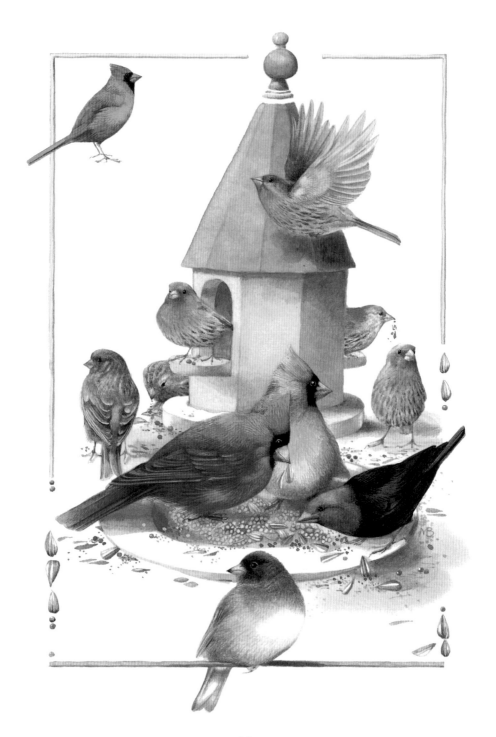

It was no longer dawn, but still very early morning when we rounded the bend and walked past the bird feeders to the sprawling expanse of prairie that spread far in all directions. As always, the feeder was enjoying brisk action. It was never totally abandoned, day or night, but dawn was rush hour at the fast-food counter. It was busy that morning, especially with many working mothers finding sustenance for their brood.

When I came to Missouri in spring, the air was filled with romance and courtship. On this occasion, the results of all that wooing, trilling, and fancy dressing were everywhere. Parents were diligently feeding their young, or demonstrating to adolescents where the finest food could be found. It was an interesting merger between wildlife and human intervention. A female goldfinch fetched thistle seeds for her fledgling, who sat just feet away, waiting dully for the handouts to be served. On the other hand, a female cowbird ate blithely without a care in the world—her fledglings were being raised by a cardinal. Meanwhile, other parents were catering to whatever came from their nests.

There was a flurry of fluttering on the wing, but the ground was also covered with the feeding station's clientele. Something about the mallards delighted Marjolein. At first, I thought it was merely the fact that mallards aren't frequent residents. But Marjolein always seems to have some deeper agenda.

Missouri, July 2003

That's my childhood. The ducks bring back all of my happiness. Wrapped up in that waddle and that honk is the time when I wasn't me yet. I wasn't human so much. I was a natural animal then, and there was no today, no yesterday. No plans. I had no responsibilities. Just to be there and take in.

Even for me, without all the associations, it was reassuring. Despite heat and hardships, business was as usual. Life goes on. A rabbit was nibbling on the grass, stretching himself, oblivious to our presence. "When he doesn't run off afraid of us, we have to wait for him."

The sun was already prodding the prairie to hurry about its business before the long, languid day. And as we emerged from the shadows of the trees, as we began wading through the paths in the prairie that the Bastins had worked so hard to restore over the years from cornfields, the first thing Marjolein did was stop and smell. There's something a little undomesticated about Marjolein; there's something a bit wild about her. First of all, when she's curious or deeply serious about something, she wrinkles her forehead, dropping her bangs

into her eyes, like a chipmunk. And when she sniffs, it's with the same excited quivering and deep, quick inhalations that the rabbit uses to reassure itself.

Wherever you walk in the prairie, it smells slightly different depending upon whether it's infused with the essence of sweet mint from the bee balm leaves or some other essential oil. But the smell of fresh-baked bread seems to be the base on which other scents layer as the sun increases strength, beating down on leaves so heavily that it breaks their stomata, releasing their oils. One of the ingredients in that scent is surely the heat baking the big bluestem.

By midsummer, the big bluestem has risen from the ground to stretch skyward and begin work on its turkey-foot-shaped flowerheads. The big bluestem rules in Marjolein's prairie. When she first seeded the acreage, everything came up. And for a while, the prairie was a potpourri of all the appropriate flowers, from oxeye daisy to purple coneflower, wild indigo, bee balm, prairie larkspur, Maximilian's sunflowers, rosinweed, and liatris. Gradually, the big bluestem nudged its way into prominence. Now the hummocks of bluestem have colonized most of Marjolein's prairie. To the untrained, unsympathetic eye, it doesn't strike with the impact of a flowery expanse. But to Marjolein and to those who know the prairie, the big bluestem rises with an incomparable majesty. It gives the prairie its motion, and most important, it is adapted to endure. Even if you're immune to the soothing seduction of its bowing and dancing and the steel blue of its blades when it catches the light, its uncompromising, cast-iron fortitude demands respect.

Missouri, July 2003

When there's a drought, you cannot help but grow nervous. But deep in your heart, you know things will survive because they have their tools. They answer to these privations, they belong to this land.

The big bluestem is only part of the picture. Everything in the prairie is customized, so to speak. In *Where the Sky Began: Land of the Tallgrass Prairie*, John Madson pointed out that prairie birds must all endure intense heat and little water (Marjolein says, "Birds keep going even at 110 degrees, but they go with their mouths open"). Mr. Madson also mentioned other common traits—birds must be capable of flying in strong winds and have keen long range vision to survive in the prairie habitat. They tend to nest in the grass (half the bird species in a typical prairie are ground nesters, compared to the 20 percent of forest birds that build on the ground), their songs are clear and loud compared to forest species, and they're prone to singing on the wing. They're apt to flock together rather than attempting a solo existence.

Madson also noted that animals indigenous to the prairie have similarly evolved with certain traits. They tend to be thirst tolerant, plant eating, swift, and able to burrow out of the heat. Their fur is usually camouflaged in a tawny color, and if they're not nocturnal, are most active at dawn or dusk.

Sure enough, on that early morning in late July, the prairie was bustling with activity, and the habitat was nurturing its congregation with whatever resources it could muster. The heat wave had broken in Kearney, but not the drought. Everything was thirsty, and morning was when drinks were served, droplet by droplet.

Part of the prairie's beauty lies in its clockwork. Dawn is when the ground holds moisture from the dew. As we walked, insects and birds drank from the grass or sipped from a precious drip on a leaf's point. A painted lady butterfly alighted

on my arm for a moment, seeking sweat perhaps; "She's kissing you good morning," was Marjolein's interpretation.

And every plant on the prairie was also clad for the climate. Fragile isn't in the vernacular. Weeds by anyone else's definition, prairie plants have the tough and textured leaves that diffuse beating sunbeams. Those with aromatic leaves form a sun barrier of essential oils that protect the surface, not only from sunburn but also from the divergence in temperature between day and night, forming a blanket that lingers long enough to moderate the change. And the prairie, seen from a distance, is thick with vegetation; it knows how to protect itself.

The sun was rising rapidly, climbing its way through the cloudless sky. It was kindling the blanket below, illuminating the spider webs accented by dew.

*Look how beautiful the sun is, shining through the leaves and
outlining the spider's handiwork. The spider has a lovely cradle;
you can see her eggs shine through.*

In its particulars, this walk wasn't so different from our first walk together
in Missouri the year before. The big bluestem was taking the same
strong stand that it had established the year before. The spiders
were equally omnipresent. The sun was just as wicked as it raced
upward, glittering in the cloudless sky. But the scene had
meaning. It was filled with characters, stories, life, death and
faces. Every blade of grass was working to sustain its
existence, and in turn it hosted insects and creatures seeking
shelter. This is the essence of the heartland, and it has a soul so deep that
it stretches beyond the horizon, beneath the blades of the big bluestem.

Missouri, July 2003

*Just think how different it is now than it was then. Now, you
understand more, you trust more. Smell ... the wind is coming up.*

HYDRANGEA MACROPHYLLA HORTENSIA

PRAIRIE CANARIES

When I went out at midday, the prairie was there and waiting—all the plants that I might wish to admire were on display. Working the grasses, despite the beating sun and wind that continually whipped off my hat, were the goldfinches, clearly visible in their look-at-me outfits.

Goldfinches aren't fazed by anything. "Look at them working the prairie like happy housewives," Marjolein says. And they do have a sort of fluttery hyperactivity that would make them ideally suited to the chores of housekeeping. When the renegade thistles come out and go to seed later in the summer, the goldfinches—the prairie canaries, as Marjolein often calls them—are in their glory. Courageous birds, they think nothing of alighting just footsteps away from you if a thistlehead is the lure. Although Marjolein says that her heart belongs to the cardinal, she inherited the prairie canaries with the land; they're like family.

Goldfinches always seem to occur in pairs. Of course, the brazenly colored, varsity-yellow-and-black male is the one that catches your eye. But his mate is never far off. Rather than protecting a territory, he looks out for his mate and defends her immediate nest vicinity.

Because they forage primarily on seeds and because they feed their young on thistle seeds, goldfinches forestall their first brood until midsummer. For the first few days after the four to six eggs hatch, the female feeds her young. After that, both the male and female forage for the family until the nestlings fledge. Then both parents collect food for their fledglings for a long two to four weeks, which might explain why it's not uncommon to find goldfinches out at midday, despite weather and wind—they've got work to do.

Goldfinches are notoriously fond of
acrobatics. The strength of a stem in
relationship to their body weight
never seems to enter into their
calculations or deter their mission
when seeking a morsel of
food. And if that stem hap-
pens to be whipping around in
the wind, all the more fun, as
far as a goldfinch is concerned.
They're a lot like a two-ring cir-
cus to watch. Not only that, but
they get from place to place
by taking a route that has
been described as roller-
coaster-like in pattern. Lest you
fail to notice, they sing in
flight, a common characteristic
among prairie birds.

The meadowlark and dickcissel
are more adapted to the prairie, per-
haps, and they might have larger pop-
ulations. But they don't stand out quite so shrilly. The male goldfinch is
dressed for shock appeal. Later on, the males will molt into garb nearly as
drab as the female, which is how they spend winter. As for Marjolein, she
prefers their flamboyant phase, not only because it lends itself to art but
because a goldfinch stands out at a distance, which is the only way to
enjoy the prairie at midday in summer.

Autumn

Missouri: The Sweet Time

Autumn is a process of elimination. Gradually, the bee balm turns completely brown, and its seed cones darken. It's the same with the other blossoms—the ironweed, Joe Pye weed, coneflowers, heleniums, and black-eyed Susans slowly bow out, leaving only brown relics of what was once dazzling and will someday shine again. The goldenrods— there are 125 goldenrods native to the United States, several of which are specifically adapted to the prairie—color up to match the goldfinches and finally fade into a deep, dirty mustard hue. In the end, not much remains besides some lingering coreopsis that, for some reason, grows only in

the lowlands of Marjolein's prairie. The Maximilian sunflowers are among the last to go, but eventually they too slip into seed. In Marjolein's prairie, where flowers make up a generous portion of the overall composition, their absence alters the color scheme and the texture of the tapestry as well. But still, there's the grasses. And fall is their finest hour.

Missouri, September 2003

Autumn is in the air, I can just feel it. That's why it's so rich. Everything is abundant—the colors, the scents, and the emotions also. It's because everything is saying goodbye.

Most of us tend to see the big picture; Marjolein, on the other hand, is usually scanning for details. And in autumn, she's equally focused: parting the leaves to search for the battered butterfly with its threadbare wings, still going about its duties; suggesting a second look at the sluggish bumblebee, groggy in the chilly air. But in autumn Marjolein is more apt to talk about the prairie as one massive being. Most especially, she mentions the grasses, and how they move.

Autumn is often called the bittersweet time, but in the prairie the emphasis is on the sweet. First of all, the prairie becomes a more comfortable place to explore. The whole tempo has eased: the temperatures have moderated; there are days of rain rather than quick cloudbursts, and the soil soaks it in, storing it up for future dry seasons. Meanwhile, the grasses are gearing up for their climax. Marjolein always mentions the difference between autumn in Holland, where everything gears down, and the same season in Missouri, where the prairie stages its last hurrah.

The big bluestem has reached its mature height. Only a percentage of the overall big bluestem population forms flowerstalks in any given year, which is how

it survives the droughts and extreme weather typical of its native habitat—by saving energy. But it always makes a stand, towering its turkey-foot spikes over the rest of the prairie. Meanwhile, other grasses are crowned with glorious plumes that stir and shake like cheerleader's pom-poms. Flowerheads or not, all the prairie grasses reach impressive proportions, and their stature gives the tall-grass prairie its personality. By autumn, that personality has attained crescendo proportions. But the climax wouldn't be quite as impressive without the wind.

Tall and lanky, the big bluestem, Indian grass, and switchgrass move with the winds that sweep over the vast expanse of open land. When breezes rustle, they quiver; when the big gusts come, they bend and bow in waves that would rival the choreographed movements of the most adroit dance company. It's mesmerizing.

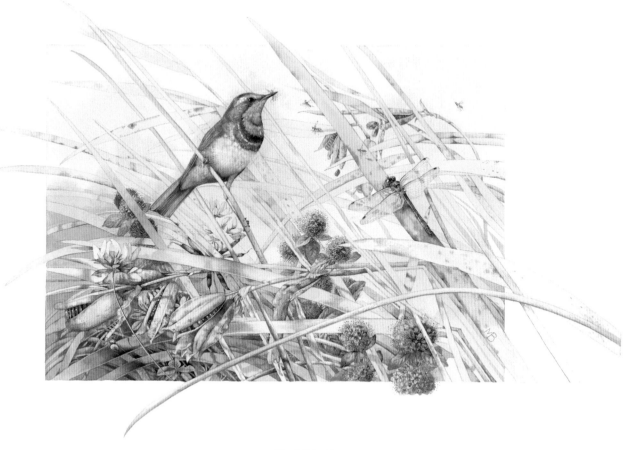

When you look out across the Bastins' land, you can't tell where their property ends and the Hallmark Preserve begins. If you walk the trails, you'll come upon signposts that distinguish one from the other. But from a distance, the vistas merge. And that's exactly what they both have in mind.

The prairie initiative began back in 1989, when one of Hallmark's illustrators decided to sell his farmhouse and its adjacent four acres of farmland in Kearney, a stone's throw from the Hallmark offices in Kansas City; and the company voiced an interest in purchasing his land. The goal at the time was to create an artists' retreat area, and toward that end, renovations on the farm buildings began. But that was only the beginning: not long after Hallmark bought the initial four acres, an additional 168 acres of farmland became available, and that was when Hallmark decided to re-create the tall-grass prairie.

The land was undoubtedly prairie at one time—most of the neighborhood was grassland. But because it had been farmed for so long, Hallmark refers to it as a re-creation rather than a restoration. When they came, no vestiges of prairie remained. But, with considerable advice and encouragement from the Missouri Department of Conservation, Hallmark began the slow stewardship that eventually brought the prairie back to life.

Mark Spencer, creative resource manager at Hallmark, oversees the 172 acres of prairie, with its three bodies of water (two ponds and one lake) and its seven miles of trails.

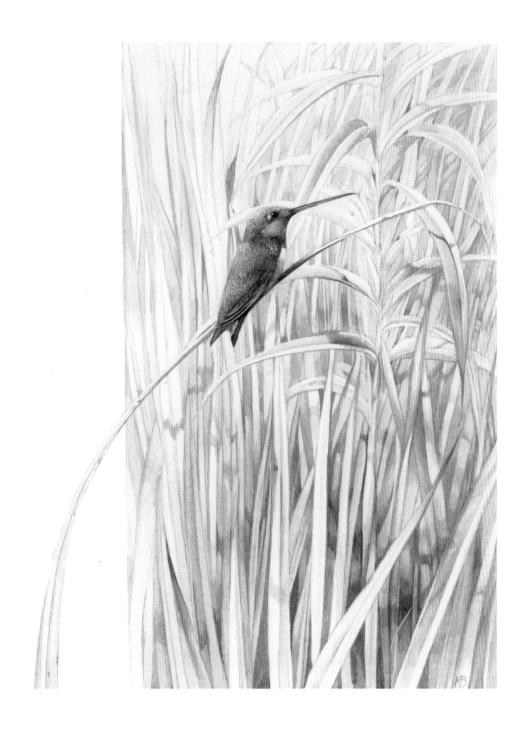

He described burning, the traditional intervention that Hallmark uses to manage its prairie.

The Bastins haven't burned their prairie yet. But the Hallmark Preserve is burned under the careful watch and professional control of the Kearney Fire Department. In late autumn, when conditions are right, the department tackles a sixty-acre chunk every year, first setting back-burns on the downwind edges as buffers. By that succession, the entire prairie is burned every three years.

Mark feels that the burns are essential. A natural process based on the benefits observed after lightning-started fires, prairie fires have been used for centuries by Native Americans and settlers. The fire removes the chaff of the old grass, letting the sun through to heat the soil, returning nutrients, and, the following spring, allowing the new blades to shoot up from the ashes. "The grass loves the burns," is how he puts it. Because the fire burns at cooler temperatures near the ground, animals and

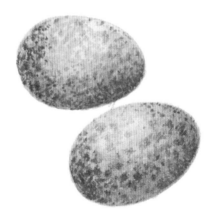

insects who can burrow down or run faster than the fire (which moves at a pace that Mark describes as "a slow walk") are not harmed. And because only a relatively small area is burned at any given time, creatures that are still active late in the season can easily escape.

Other than burning and mowing the trails, the Hallmark Preserve is left alone, just as the Bastins leave their prairie to the caprices of nature. Both share the same vision: to steward the land back to its natural state. Together, the land forms an expansive refuge for wildlife.

Missouri, September 2003

Everything in the prairie is an answer to these conditions: to this soil, to this climate.

In the prairie, you can see the wind come, and you can watch it swirl over you. You can see its direction and strength. It's like rippling water. When you're out in the prairie, you feel it running from the grasses through your cheeks and hair. Then you become part of the prairie.

Because the land was formerly cultivated for crops, Marjolein's prairie is punctuated by occasional stands of trees that prevent the wind from sweeping too violently, but also add a voice to the prairie symphony. Every prairie probably has its own music: in this one there's the high-pitched sound of branches scraping against one another, the whistle of air racing through the windbreaks, and the rustle of dried leaves still clinging to twigs. Sometimes it is so loud that we have to yell over it to be heard. On other autumn mornings, especially very early, it's so quiet and still that Marjolein claims she can hear the nuthatch cracking his breakfast, or the chickadee's claws as they land on a branch: "It's so full of tiny little tiptoe miracles."

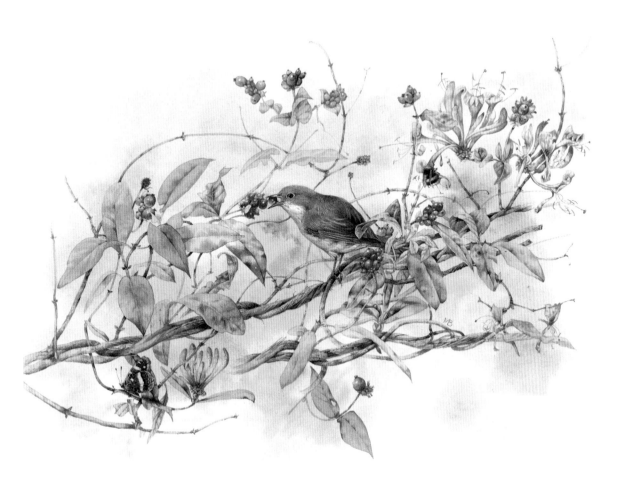

In autumn, when the air is infused with humidity, the dawn mists linger and could better be defined as fogs. They aren't confined to the pond but hang over the whole prairie, giving the place an eerie presence. Marjolein loves the thickness. She phones me just to describe a beefy, full-blown fall fog; how it hangs in space and what it hides.

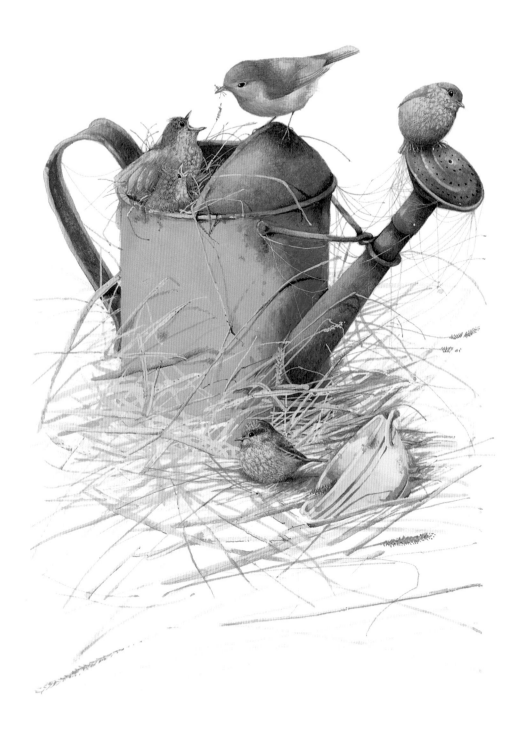

There are big fogs that last the whole day here, and I love them, they make everything so glued together. It takes away all the harshness; they give the scene depth. What is close is clear, what is farther away is indistinct, and the far distance is hidden entirely.

It's very difficult to make a fog drawing. I yearn to capture it, but I haven't yet succeeded.

Fortunately, autumn also has its fair share of glittering, crystal-clear days, which come as a relief after the heaviness of a Missouri summer. They have too much contrast to be captured photographically, but Marjolein can filter some of that out. The same scene, photographed in this light, would be overexposed and washed out. But when Marjolein paints, she depicts color as it's interpreted through the eye. Her goldfinches glisten, and her hummingbirds sparkle in jewel tones.

Missouri, September 2003

There were eight hummingbirds at my feeder today; yesterday there were none. That means that my hummingbirds have left, and today's group is just passing through. They will fly over the Gulf of Mexico, so they will get a head start.

The slightest breeze of wind loosens the leaves in the trees. Fall is like watching someone stepping out of a dress, and their whole outfit is lying on the ground at their feet.

Even though autumn has a vivid palette all its own (Marjolein often says, "I love autumn the best. But did I say that also for spring and summer?"), part of the beauty of the extravaganza is its pace. The light falls on a scene that is changing its wardrobe. The big bluestem is famous for its varied autumn color, slowly turning more orangey yellow, blushing into ocher with golden tips, contrasted by a bluish base. Overall, it forms a golden tapestry of several shades, so that when the grasses bow in homage to the wind, they ripple with a peacock effect. It's a phenomenon that must be seen, another compelling reason for Marjolein to live in the prairie. She needed to watch the spectrum constantly changing with the lowering sunrays and crisp nights.

Everything is wrapping it up, readying for a time of rest. As for Marjolein, she's too philosophical to slip into melancholy. She extracts meaning from it all. The poignancy of the rose that's spending its last gush of strength in blossoms ("with imperfect, damaged petals perhaps, but that's part of the beauty") has a pride that doesn't provoke pity when she draws it. The stark brazenness of the tree that suddenly stands naked when yesterday it was clothed seems more like a meaningful parable when she describes it.

The prairie gradually sheds all its secrets, becoming less of a place to hide and more of an environment for seekers. The birds that stay behind—the ones that don't migrate to more temperate regions—flit around with even less shelter than before due to the newly denuded trees. Without camouflage, their comings

and goings are suddenly everyone's business, which is a boon to Marjolein and her binoculars. But predators also benefit.

In the garden, everything is gearing down, and Marjolein's autumn drawings are more apt to show tatters, decay, and slug nibbles. Beneath it all, there's a lot of scurrying for survival—the eaters and the eaten, the acorns and the squirrels that harvest them—there's a new crop of berries and rose hips to be stripped by migrating birds. In a bountiful year, there will be hackberries and dogwood berries for the robins that remain. Often the overripe crabapples in the garden ferment during Indian summerdays, leading to a circus of drunken bird antics.

A family of raccoons wades through the river, trawling for crayfish, gorging themselves plump. Meanwhile, the beavers are building their winter abode on the shores of the pond.

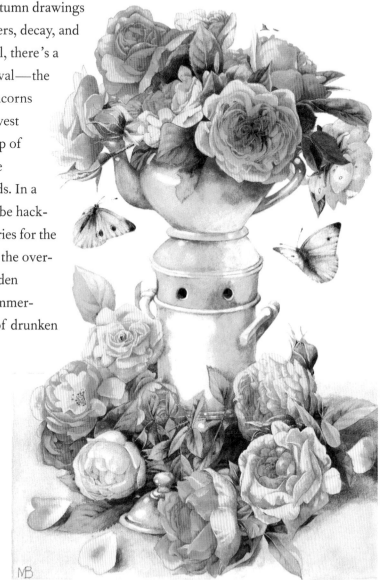

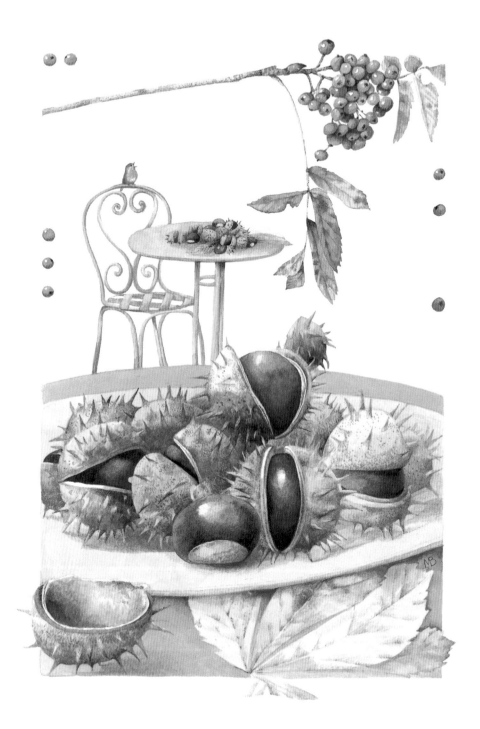

They're making branch nests. I watched as a couple went swimming just a few feet apart. And when they saw each other, they swam over and nuzzled each other playfully. It was so personal. Never say that an animal doesn't have feelings. We might be more refined. But they have feelings just as we do.

The prairie is winding down. It's investing in its future, putting things in the bank, sending strength back into the soil. Even more than spring, it's a time of renewal. Marjolein always mentions that aspect of autumn; she talks about the hope.

The Goose Pond

Every evening Marjolein and Gaston eat dinner outside. Gaston always sets the table, Marjolein works up the menu, and then they convene on the terrace for a leisurely meal. More often than not, dinner seems to be punctuated by cheeses and breads, in the European manner, and it's timed to coincide more or less with the sun's setting. The goal is to finish eating just about at dusk; dessert should be served when the geese fly in.

The pond was originally Gaston's idea. With architectural as well as photographic roots, Gaston is fond of all things scenic. He loves a flowing line. And he's not above creating a little magic, when it's within the realm of possibility. That's how the pond began.

The pond was carefully thought out for everyone's benefit. Its banks aren't too steep, the better to accommodate ducks and geese who find land maneuvers considerably more cumbersome than flight. If geese had their druthers, they'd select a water hole without a lot of undergrowth around the shores. Not only aren't they particularly adept at waddling through rough vegetation, but reeds and whatnot aid enemies (i.e., foxes) in their stealth missions. Canada geese have never struck me as among the more brilliant of God's creatures, but they seem to have figured out survival.

And the Bastins are accomplices, doing everything within their power to help out—like mounting a washtub on a pole above the pond for nesting purposes.

Of course, there were lots of interested couples and only one washtub. Canada geese being notoriously outspoken, the initial argument over the prime real estate was ugly. But when the winning couple settled in, they held firm for the tedious thirty-day incubation of their eggs. Marjolein has nothing but sympathy for any creature whose plight entails a month of bed (or nest) rest. ("Thirty days of sitting still. Imagine.") But not everyone is willing to shed a tear for peevish fowl who spend their confinement lounging on a warm nest punctuated with frequent snacks delivered in bed by a doting lifemate.

The Canada geese are definitely the pond's most vocal incumbents, but they aren't the only creatures to reap the rewards of Gaston's engineering. The Bastins had the pond stocked with fish, a process that entailed installing a serial progression of small species, starting with small minnows and working up to the

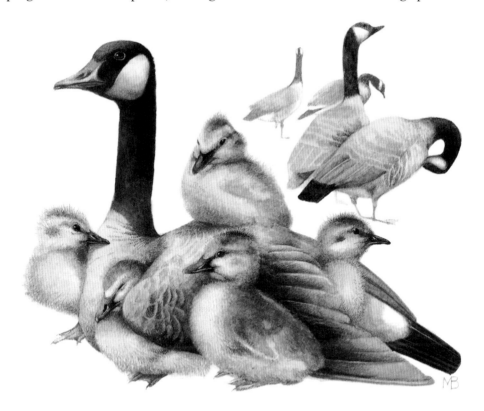

deluxe residents—largemouth bass. And the kingfisher took full advantage. "He torpedoes the fish," is Marjolein's take on his table manners. "Often he misses. Sometimes he succeeds." She also witnessed some interesting adaptive behavior. Particularly resourceful, her kingfisher took control of a pair of Adirondack chairs on the floating dock. For a while she assumed that he'd just discovered a convenient and efficient lookout point. But eventually, she saw that he'd found another use for the chairs.

Missouri, September 2003

He takes the fish, flies back to the Adirondack chair, and kills the fish quickly and professionally by beating it to death on the armrest. It must be a tender dinner.

The kingfisher plies his trade by daylight, but the geese spend a good part of the day on sightseeing tours. Just as dawn is gearing up, they move out. In autumn, their departing flight is generally shrouded in dense fog. By the time the sun has risen in the big Missouri sky, the pond has quieted down; the fog and the geese are mostly gone. The geese take off with minimal fanfare: if you don't happen to be watching, they slip away—floating off like the mist.

Their arrival is not similarly discreet. At about seven-thirty, as dinner is concluding, Gaston puts down his fork, checks his watch, and scans the sky. Sure enough, the Canada geese begin to pour in. Every night, same time. Punctual.

The geese come into the pond in relays and with a flourish. Each batch makes a few carefully choreographed turns to land against the wind, flight maneuvers that would seem graceful and poetic were they not accomplished

with such hysterical heralding. Nor is that initial ranting the end of it. Once safely in the water, the flustered settling-in ritual of flapping and scolding ensues, continuing in waves with each new flock of arrivals. According to Gaston, there's a pecking order at the pond. Only an elite group of geese are given permission by air traffic control to land. Undesirables are driven off.

The scene finally settles down—sort of. In fact, the geese go through squalls of hysteria all night. I listen from my bedroom, while Marjolein stays tuned in her studio. Next morning, she'll recount a play-by-play of the turbulence in the pond, in her prairie, and everywhere else within earshot. The sounds don't really disturb Marjolein, even when they break the silence of the night. She just continues with her work, dabbing her watercolors and recording what she's come to understand about the cloudless sulphur butterflies that day.

Meanwhile, the wind that teased the prairie grasses all day is quieting down. There will be frost on the penstemon by dawn. And some morning soon the sun will rise to a thin layer of ice skimming the goose pond. Winter is creeping into Missouri.

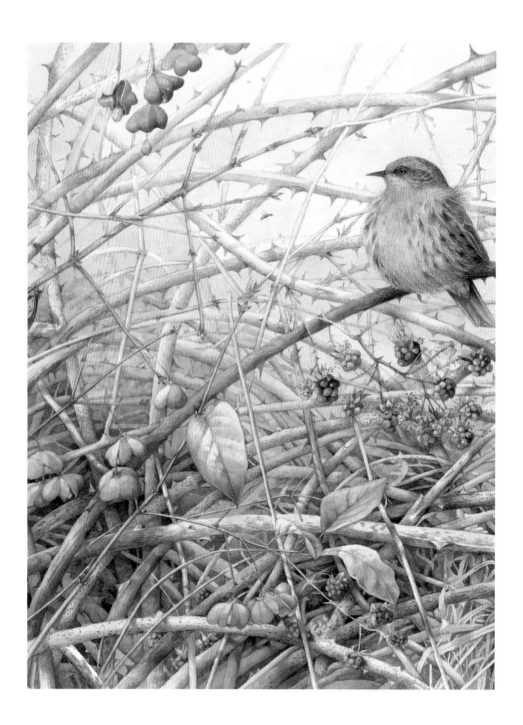

Winter

Missouri: Adaptations

I see almost nothing. Looking out over the vast stretch behind Marjolein's house in January, I find it devoid of anything to arrest the eye or capture the imagination. The desolate fields, the forlorn expanse of muted colors—the forbidding dullness of Missouri in winter is sufficient to stifle anyone's spirits. Anyone else would yawn, roll over, and bide her time until spring. But Marjolein finds the scene riveting.

Last night there was a light frost with a little mist at dawn against the sunlight. The beauty of the mist lies in its changing. It grows thinner and thicker, and it lifts and settles, leaving everything edged with a delicate rim of white lace. Sparks of light are hidden in every mist; they make me breathless. On mornings such as this, I am not able to put anything on paper. I am just in awe.

Marjolein is talking mists again, this time laced with ice crystals. On some winter days the mists form the main attraction in Missouri. But more often, the skies are clear, and Marjolein exalts in the canvas spread before her, and the fact that winter lays everything bare.

There are no one-dimensional fields for Marjolein. Beyond the strictly visual picture of her backyard, there are subtle sounds, scents, and sensations adding breadth to everything she experiences. Life for Marjolein is so dense, in fact, that she is constantly frustrated by the limitations of her medium. If it were possible, her drawings would express the crunch of the ground underfoot as much as the journey of the crumpled leaf scuttling along the prairie. That single threadbare, creased, and wrinkled leaf says as much to Marjolein in its starkness as the colorful barrage of summer; if only she could coax everyone else to comprehend its splendor. As an artist, Marjolein's ulterior motive is to bestow credibility on that brown and brittle leaf. She can't understand why such wonders of nature are ignored in favor of glitzy showstoppers. The stars already have a following; it's nature's supporting cast that needs press coverage.

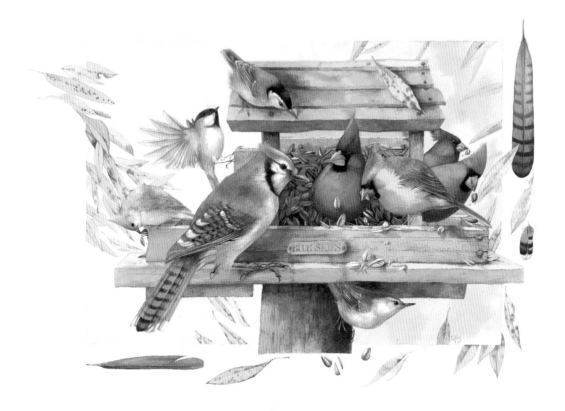

Sometimes I know that my drawings of the little nibbled leaf or
the crisscrossing pine needles will never turn into greeting cards.
But you've got to say that thing anyway, you've got to point out
what we overlook.

Even the brown dead leaf touches me, it moves me, it speaks of
aging and all the life that was there. That life, humble though it
is, will be food for the future. Every layer is life for the next
generation.

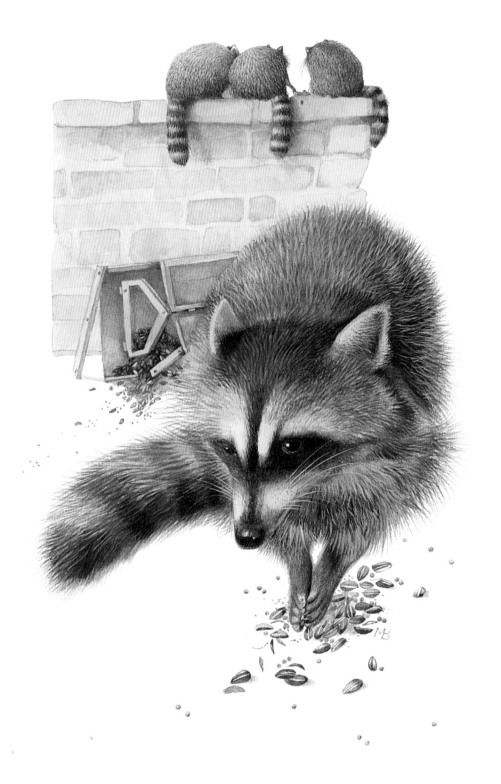

To my eyes, Missouri is a vast expanse of
unremarkable elements in winter. But to
Marjolein, each grass blade in the matted and
disheveled prairie holds a harvest of seeds
for a hungry forager. The berries still
clinging to the trees and shrubs, combined
with whatever insects can be found and, of course, the feast at
Marjolein's bird feeders, sustain the black-capped chickadees, blue jays,
bobwhites, raccoons, and cardinals that stay as permanent residents.

Missouri, January 2003

Winter is more introverted in its landscape than any other season
of the year. Beneath that matted grass, I know I will hear mice
scratching. It's a totally different focus, and enjoying the leftovers
can be extremely rich. I can't eat enough with my eyes.

Marjolein can see across for acres in winter—a fact that holds enormous
promise for the environmental eavesdropper. With the field rumpled by wind in
early winter and later reduced to a brown mat laid flat by snow, with the trees
stripped naked of leaves, Marjolein finds herself surveying a vast stage.

I can sit at my desk and watch the movement of the grasses. They
dance in tremendous undulating waves as the wind blows. They
move in a rhythm of bending and straightening, bowing in
obedience—because, if they don't bow, they'll be broken. You can
feel them suffer, you can hear them groan.

Although it's not really a time of courting or mating (with the exception of
the red-tailed hawk, who begins to nest in February), winter has its climaxes.
Every creature that remains awake and prowling must eat through the winter. For
some, scavenging food is more challenging than for others—for the mouse, it's
just a matter of successfully discovering a trove of seeds and scattering their
contents, or ravaging a rose hip; for a fox, blood must be shed. That's the way of
the natural world no matter when you tune in. But in winter, the bared landscape
leaves no place to hide. Even worse, the "bloodshed" often happens in plain sight.

When the kestrel swoops down to the birdfeeder, it's not a bloody
thing; there's not much blood shed. It's a needle-sharp pierce from
their claw to the heart or a break of the neck, and it's over. After
all, blood is essential for nutrition, they'd better not waste it.
That's the precise efficiency of nature.

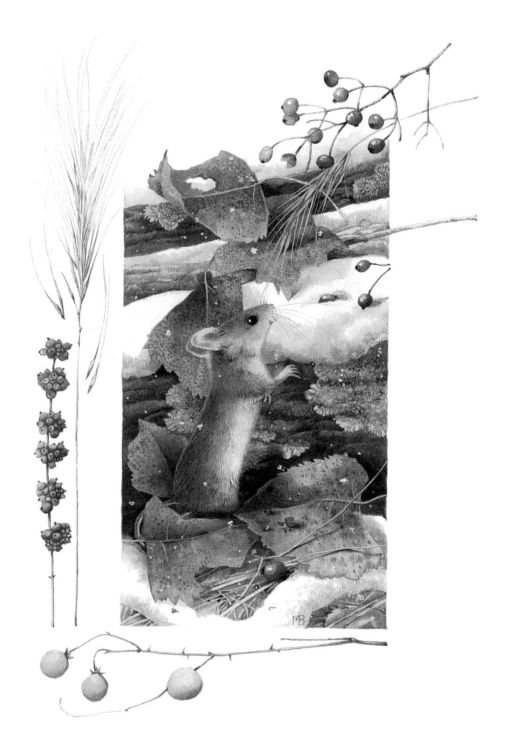

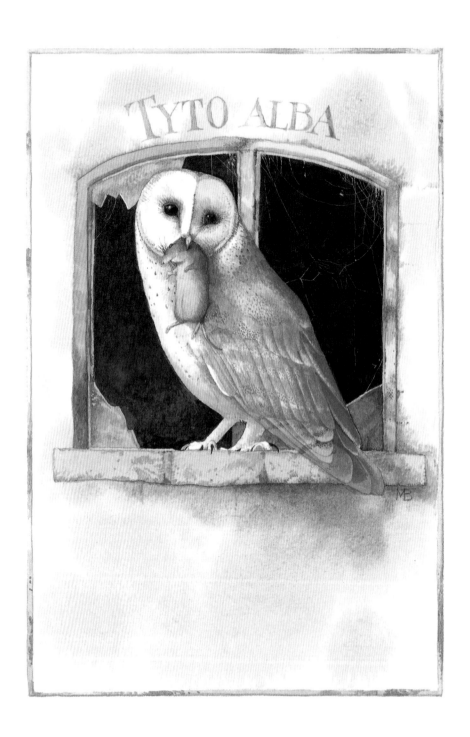

Most of the time, Marjolein watches a peaceable kingdom from her windows. But there are moments of high drama. Kestrels swoop down on the feeder and snatch up chickadees caught off guard at the feast. Foxes chase rabbits, disappear into a thicket, and emerge nonchalantly with their catch dangling limp between their teeth; opossums waddle clumsily around, eating whatever happens to be readily available. In the naturalists' eyes, there is nothing reprehensible about the predator. A hawk's deftly executed, split-second maneuvers have all the beauty and danger of a circus trapeze act. And Marjolein is transfixed, her voice tinged with high-pitched excitement whenever she has the privilege of witnessing nature's survival act. She applauds "the bowels of nature," as she calls it, simply because it is necessary.

Missouri, January 2003

I hope we have snow, to read the ground for tracks. You can see who was there, you see what has happened. You find the cushions of hair and the telltale feathers from the fox's meal or the coyote's dinner. You see evidence of the little struggles.

People always talk so low of the coyote, but he's as beautiful as a wolf with his big downy coat. The coyote isn't evil. We don't want to see suffering, we don't want to witness death. But even when there's tragedy, it's food for someone else. We love owls, but we don't like to see them kill. And yet life and death are part of the cycle that is nature. Without that cycle, the world wouldn't exist. You can't say this fact of life is true, and yet the other reality is repulsive. The whole cycle is truth.

Even in winter, Marjolein is incapable of sitting complacently at her desk and receiving input secondhand. Instead, she's compelled to perform primary research. And that interaction brings her into direct combat with the elements. In most seasons, nature walks are a delightful sport. But not in winter.

Missouri, January 2003

I've never felt such bone-chilling cold as in the Missouri prairie. I dress myself like a bandit with so many layers—buried in Gaston's huge mittens and wool wrapped around my head so that only the slits of my eyes show.

But I have to go out. Some animals live out there, so I must go out. The wind speeds up and rolls down the hill; the only shelter is against the tree line that halts the wind. But I want to see the deer and the cottontails, so I go out.

No one wants to be a naturalist in winter, when every step forward is an assault against the wind, and few sensations compare in level of trauma to a confrontation with the Missouri wind. Just as the only bodily defense against the blistering chill is to bundle up, the only rebuttal to winter's brutality is to wax philosophical.

In an extremely clumsy way, the senses are a tool to play with against the elements. You use your cold red nose and your eyes squinting against the wind's rush; you walk with sore toes and heavy feet. You are more aware of every sense, you have a mission. When you walk in winter, you are on the defensive. You've got an expedition, and you've got to survive.

You respect every animal in winter. Each and every one is a hero, and you suffer with them. You trudge along with your feet in the snow, just as they have their feet in the snow.

In her own way, Marjolein is gathering sustenance. She needs to reacquaint her eyes with the colors, to reinforce the sounds echoing in her ears.

<div style="text-align: right">

Missouri, January 2003

</div>

The first thing that I sniff when I go outside in winter is my childhood. I inhale the smell of frost in my childhood garden. And when I look, I see the balloons of air under the ice in the puddles that fascinated me as a child. I remember sitting on the sleigh over slick and slippery roads, people skating across the river and my mother taking me on long, slow walks. When I open the door in winter, I sniff my childhood in Holland.

Marjolein always starts any walk with an internal warning, like a prayer mumbled before battle: "I might find nothing." But the fact is, she couldn't possibly return home from a walk having learned nothing, because she asks so little. She needs only a new scent in the air or a slightly different shade of copper on a dead leaf. She goes out looking for stones and twigs, she walks the fields listening to rustlings beneath the folded grass. And she comes back home bubbling with excitement about the bark on the sycamore tree. Winter might not be capable of delivering a bounty of newborn fawns or chicks learning to fly, but that's fine with Marjolein.

*The first step outside defines every morning from the day before
and the day after. Every day smells a little different. Winter scents
are so strongly developed, so intense. The smell of frost has such a
distinct scent—it's stiff and crisp, like a little shock.*

She uses the play of colors to describe a scene so precisely that you feel as if
you're sharing that picture. Even in winter, when everything is muted, she still
describes the more subtle play of shades.

*There's not just one winter light. More than ever, the light that
washes winter is a reflection of the sky. In summer, we don't notice
the color blue or the gray of the sky because there's so much to
distract us on the ground. In winter, the sky looms in front of us.
In winter, the sky responds totally differently to the earth.*

Marjolein appreciates the dingy whites and drab grays of winter, but she's
also aware that other people crave a spark of color, and that's what she hunts for in
winter. She wants to paint the cardinal that matches the ilex berries and the rabbit
that will make a path through the otherwise expressionless fields of snow. For
Marjolein, that's the dialogue of her art.

There were those dull ocher fields stretching before me, and suddenly I saw a blue jay, the sun catching the feathers on his back. And then the fields were golden against his fierce blue spark. From that moment, the color of the fields had a function; they were talking to the blue.

Marjolein sees herself as a sort of translator of light. She finds light in the dawn mists and in the reflection of the snow, and her drawings ask us to make similar mental excursions. Even if she fails to convince the world that there's a kingdom of beauty beyond the obvious heart-stopping 'New Dawn' roses and weeping cherries; even if she can't coax us to empathize with the coyotes or the homely opossums of the world; at least she's attuned our eyes to perceiving the sparks of light in the landscape. Once you've begun to notice the relationship between the song sparrow and the bleached winter grass blades or the pine siskin against the swamp reeds, you will never again feel dull—even in the depths of January.

THE CARDINAL

Maybe it was the concept of the prairie that brought Marjolein to Missouri, but more directly, it was the cardinal she first encountered during one of her early visits to Missouri.

Missouri, January 2003

Although I'd seen pictures of cardinals, and I knew that such a bird existed, I'd never seen a real cardinal before. It was a shock. You wouldn't invent a bird like that. And the fact that he's shy, usually in the background, that also amazed me.

At first I thought that the male was most beautiful. Now my love goes to the subtlety of the feathers on the female, with her lipstick red beak, so fiery red.

It makes perfect sense that Marjolein ultimately came to America to be close to a bird. And the fact that cardinals remain in Missouri throughout the year was also a strong incentive. But it was the enthralling domestic life of that particular couple that won her.

Marjolein is a romantic. You can see it in her relationship with Gaston and the way she selects her friends. The cardinal, for all his striking plumage, would be little more than a passing exclamation point were it not for the fact that he's gallant far beyond most of his feathered counterparts.

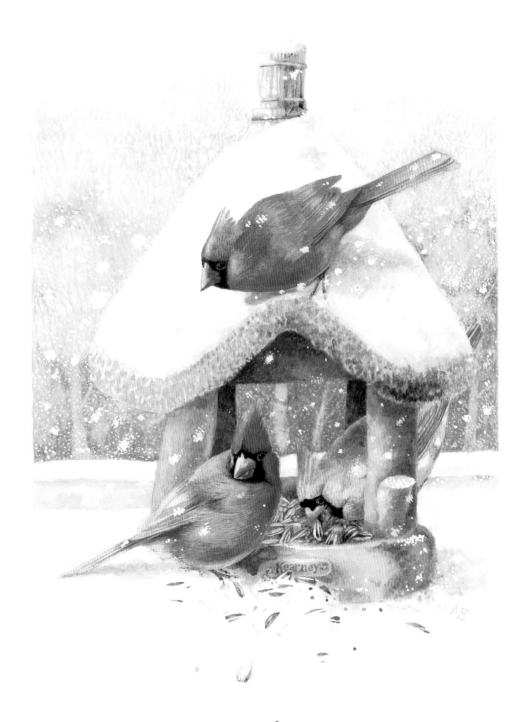

Missouri, January 2003

That cardinal, when I saw him, was totally focused on his love song. Forgetting everything around him, his song is like a soft violin.

Not many female birds sing in response to their mates. But cardinals do. When he sings, she responds with a voice not quite as powerful as his. And when they are mating and when she's incubating the nest, he feeds her all the time, gently putting some morsel down her beak. It melts me.

There are benefits to being big and bright red. Because their plumage is so prominent and their size intimidating, cardinals can afford to be polite rather than bullies (blue jays, take note) at the bird feeder. When a cardinal comes to your feeder, you're apt to notice.

Grand Cayman, March 2003

When Mischa phoned yesterday, I suddenly heard in the background the song of the male cardinal, and it transported me immediately to home and the prairie in Missouri. I could hear spring and the urge to start a new season. In his own way, the cardinal was singing a victory song—he was singing about victory over winter.

Grand Cayman

As Marjolein often says, she loves and needs winter. She wants to experience the slapping chill of frost against her cheek, smell the nip in the air, and feel the bite at her toes when she goes out on her walks. She loves surveying the blanket of snow and reading the telltale footprints of the creatures as they scurry into cover from the cold. She just doesn't love or need four months of that sort of thing. That's why the Bastins have a house on the Cayman Islands.

Grand Cayman, February 2003

I couldn't live on a tropical island always. I'm born to a country with climates, and I'd miss the fall with the moisture in the air. I'd miss the changes in temperature. In the winter, it's always around 80 degrees here. Everything is blooming all the time; all year the bougainvilleas blossom.

I love seasons. But still, there's a magic to coming here. The moment the door is thrown open on the plane, you think, Wow! and it's totally around you—it's summer.

Marjolein doesn't go to the Cayman Islands to vacation; she always makes that perfectly clear. She can produce quantities of work while hidden away in what might be called intensive seclusion. And it's not only about finished products. Undisturbed, given time to observe, to study what she holds in her heart, she can reconnect with the soul of her work.

It's a time to step back. I don't have to meet with anybody, I can just sit behind my desk and focus. My life is not as relaxed as it was—every year, I seem to do more. Here, this is a place where I can crawl back into myself, while outside I'm touched by warmth and sun. It gives me a feeling of peace. As I'm working, I'm overlooking the whole blue ocean.

The ocean has such a calming effect on your life. You can't speed up a wave, it follows its own rhythm. And it invades you with the same calm.

Marjolein resists the urge to chronicle nature in the Caribbean: her mission is to make us look more closely at the details that we encounter every day, and most of us have never been to the Cayman Islands. Every once in a while she does a drawing of shocking pink hibiscus in a bouquet with eye-popping bougainvillea, or some other tropical combination. She did a drawing of the sea grapes that she admires. She once portrayed the parrots in their camouflage green feathers. But even though she has a home on Grand Cayman, Marjolein still considers herself a stranger. She explained to me that it takes time—many seasons—for her to settle into a place and "know" it with the intimacy that she requires. Which is why she doesn't often vacation in unfamiliar places. Instead, Marjolein returns to an environment over and over again until it becomes a touchstone. And she's only truly comfortable when she can call that place home.

This is so new to me, it's a world that I never dreamed existed. Everything here is beyond my imagination. I don't speak this language, but you slowly grow into a country. You begin to know when the birds are breeding, and you learn how fragile the coral reefs are as an environment, about the harm of the salt spray and being aware of the wasp nests. You watch and learn.

That intimacy is possible in any place. It's not about where you are, it's how you perceive it. It's about how you feel, and then everywhere you're at home.

Marjolein gradually grew to recognize the "vacationers" as well as the "residents." Now she talks about the black-bellied plovers, semi-palmated plovers, ruddy turnstones, and whimbrels that fly in to spend the winter, sharing the gentle climate of the Caribbean. She revels in the piercing yellow banana quits that flit around as much as she thrives on the sphinx moths, the gulf fritillaries, and the zebra butterflies that work over the tropical blossoms of this subtropical climate.

Marjolein phones to tell me stories about kingbirds dropping lizards on her shoulder. She talks about the heavenly blue, chameleon-like anole lizard and straining her eyes to distinguish crabs that are the precise color of beach sand. She describes the herons (green-backed, little blue, as well as tricolored) that come at sunset to fish in the mangroves, and the snowy egret that forages in the sea foam of the ocean waves. But Marjolein also likes to feel connected, she wants to be part of the action. When the lion lizards began begging for scraps

of cheese at lunch, Marjolein figured that she'd been accepted into the community.

Grand Cayman, February 2003

I wish that you could hear it. All around me, there's the constant yelling of the cicadas and the locusts everywhere here, while the crickets sing their little bell songs wherever they are; everywhere they sing.

You smell the moisture in the air, and it's a wonderful tropical smell. And the palm trees make the breezes visible in a dance that sways with the movement of the wind.

As much as she's lulled by the Caribbean gentleness, on the one hand, Marjolein is respectful of the elements on the other. It's not all perfect in paradise, nor does she want a life without danger. Often she tells about the sudden rainstorms that come swooping in, dropping buckets of water from the sky, filling the cisterns to bolster the island's supply of fresh water.

*I so often have the feeling when the wind runs over my cheeks as
though someone loves me and is touching my face, caressing my
skin. And I think about the wind coming from Panama and places
that I'll never see, and I imagine that I'm touching South
America. The wind is warm; it's body temperature, and it's so
tender. But in a storm everything is more pronounced. And it will
hit you and it will pain you and it will throw leaves at you. You
might be blown away.*

Marjolein likes the intensity, the infusion of sparks and excitement that
tingles her senses. Even if she doesn't constantly illustrate from the nature around
her, she draws strength from it—if you look closely, you can see it in her work.

*The colors are indeed so bright here that you have to swallow hard
and catch your breath when you look at them. The sun is so direct,
strong, and murderous that at noon you don't have a shadow, and
you have to look for the massive leaves of the sea grapes and the
palms for shelter.*

*It's because of the light that the flowers are so vibrant and you
have to blink your eyes. It's so harsh, it makes you dizzy.*

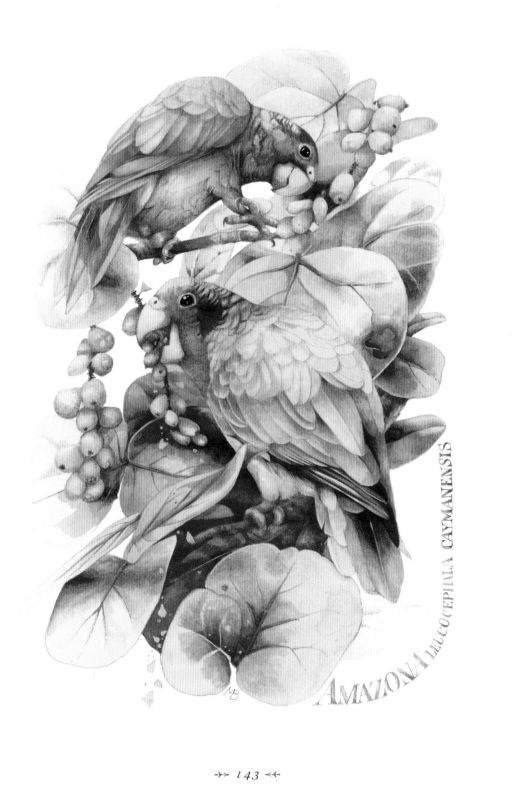

AMAZONA LEUCOCEPHALA CAYMANENSIS

By day, it's almost too much—especially in contrast to the extremities of winter in Missouri and Holland. But I'm not sure that Marjolein goes to the Caymans for the days. Quite often, she talks about the evenings and nights on the islands, when there is no sun to contend with or hide against—when she need not put on sunglasses.

Grand Cayman, February 2003

Tropical nights are long and dark, and I always have to go to the beach and feel my body wrapped by the hot air. And you can hear the break of waves, and see the moon and stars glitter in the ocean. There's such a velveteen night here in the Caymans.

In Missouri, the night is night and you turn inward. But here, you must go out into it.

Marjolein and Gaston always schedule their visit to the Caymans so that winter is almost over when they return to the States. On one hand, Marjolein is sorry to leave her solitude, to be tossed into the fray of meetings and phone calls again. But then she wonders whether her purple martins have returned, and she wants to watch their courtship. She wants to listen to her cardinal's song again. So in the end, she can hardly wait to travel back to Missouri and rendezvous with the first inklings, sprouts, and chirps of spring.

Missouri:
Talking Back and Forth

Marjolein is always pointing out potential drawings. She can't walk down a path or see a squirrel in the woods without mentioning that someday that creature, insect, or blade of grass will be translated into watercolors. That tendency doesn't cease in winter; if anything, it's intensified when desk time becomes disproportionate and excursions become a major effort.

But what's going on outside doesn't really matter, because Marjolein has such a store of images stashed away in her mind that she could continue working indefinitely without seeing another spring. If anything, her pace becomes even more feverish. In winter, Marjolein devotes hours to intensive drawing sprees, documenting the simple roadside chicory of seasons past or the ephemeral color of an indigo bunting. It's as if she feels compelled to put her entire inventory of memories on paper.

Missouri, January 2003

I never get eyestrain. At first, years ago, when I began working professionally, my back, neck, and eyes ached so much that I went to the doctor. But I've adjusted to it. My whole spine has grown to fit my table, and I feel perfect while working.

I've specialized, just like nature specializes. Not only have I adapted my body to my desk and my task, but I specialize in memories. When I make a drawing, it's life. It isn't a drawing; it's real.

Marjolein cannot help but draw. In her shoe box of family pictures, there's a snapshot of Marjolein as a young teenager, immersed in a drawing. She's been communicating this way for as long as she can remember. It's her way of sharing what she sees with us. And there's always an undercurrent of missionary zeal. Marjolein once mentioned that she could have been an environmental activist in her youth. Instead, she took a more subtle route toward spreading an awareness of nature and its fragile balance.

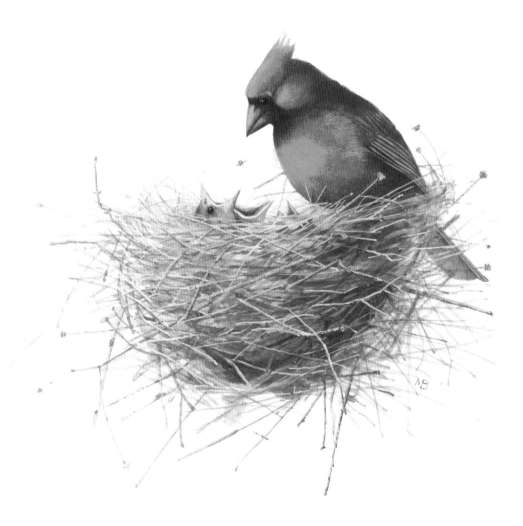

Painting is like a language to me. I use it like words. I dare to say more with my brush than I do with speech. It's a very honest and open way to say to people that they should look and observe.

Drawing is translating beauty on paper. We all have nature around us. When I put it on paper, people open their eyes to it because it's art. It's a sort of bridge between reality and our eyes.

Marjolein was rarely painting when we talked. Occasionally she worked while we listened to opera together, and she always took the opportunity to draw when I went on a solo walk or when I rested. On my visits, I saw pencil sketches and finished paintings, but I never witnessed the entire process from start to finish. Once, I wondered aloud how she did it. That query opened a floodgate: if there's a subject that Marjolein warms to, it's drawing.

Just as I must be at my computer in my quiet office with my notecards stacked on the righthand side of the desk and some snapshots on the left before I can write, Marjolein has her set of essential components necessary to create her work. Where she is doesn't matter; she can be in Holland, Switzerland, or the Cayman Islands. The time of day (or night) doesn't affect her work; she can work with music or in silence. But she must have a white desk. "Even the water for mixing my watercolors must be absolutely clear to begin with; I just want to concentrate."

Each drawing begins with a thumbnail sketch the size of a postage stamp, scribbled in faint pencil on a tiny scrap of paper. "The idea, content, and composition—everything is in that thumbnail sketch."

The initial sketch changes as the work evolves, but it furnishes an essential starting point, helping Marjolein to overcome the artist's version of stage fright that accompanies the inception of each project. Although Marjolein completes several drawings each week, she still regards every blank piece of paper with trepidation.

Missouri, January 2003

I'm very shy when I start a drawing. But the sketch leads me through that fear. Then I'm not working with a big white blank space staring at me. I can feel the borders.

In all the time we worked together, I never saw more than one version of any drawing. Any changes are worked out on the original sheet. Marjolein's wastebasket is always empty.

Missouri, January 2003

I sketch very carefully in pencil to show what I want. It isn't exactly the same as the thumbnail; I play with the drawing space and what is left. It's not only what you are drawing, it's the space that you leave blank. A drawing is like talking back and forth. Certain things become hurt if they're crowded.

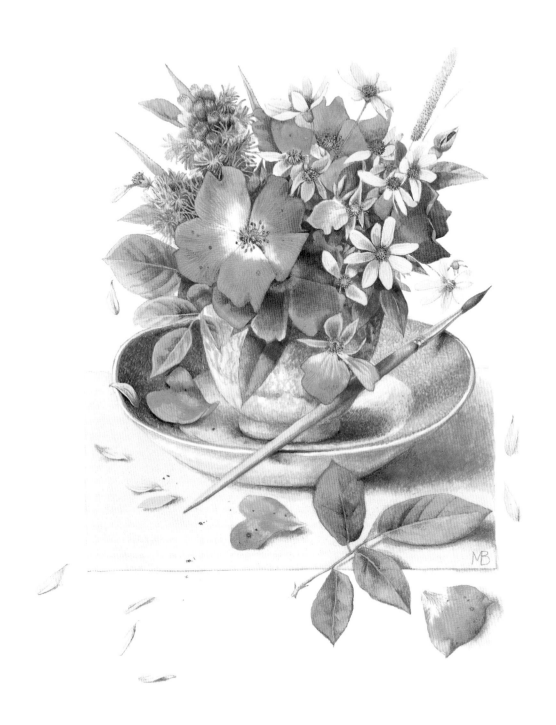

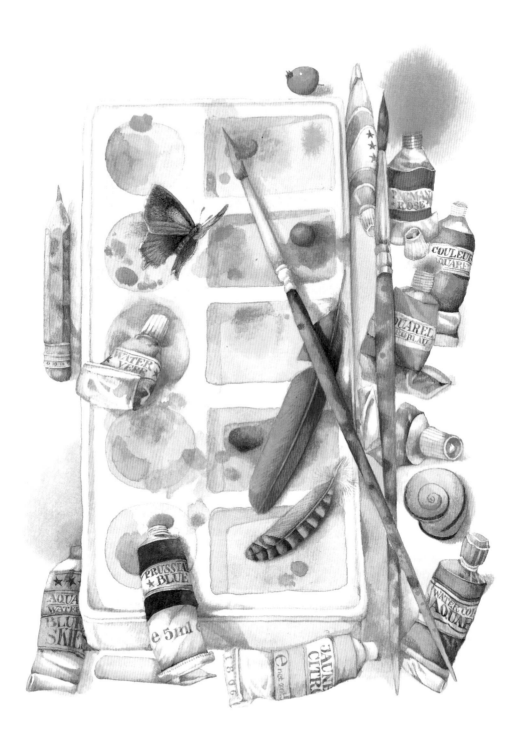

Then the watercolors come. Marjolein once told me that she never makes color notes while in the field. "Color is dictated by nature," she said. "When color isn't right, it doesn't feel good." That's her photographic memory at work, subconsciously recalling the precise hue that she saw. "But I'm not thinking about color," she once explained; "it just happens."

Her desk has no more than seven basic tubes of color within reach; each tube lasts more than three years. Marjolein works by starting with tiny daubs from her tubes, diluting and mixing them on her palette to create the precise colors that she remembers. It's a creative process that is based on reality, but also has a bit of magic to it. "I'm a wizard of sorts," Marjolein once said. As it progresses, each painting gathers a momentum of its own.

Missouri, January 2003

As I work, I thinly bring the color up, and that will be the painting. I use a certain color or line, and it must be followed by another color or line. It's a constantly moving thing.

I always have a sense that I'm doing ballet on a stage. It's like dancing on paper—swirling and stretching. As I work, I have a feeling that this will be the best drawing ever.

It's true, when I speak with Marjolein at a certain point in the progression of a painting, she's all aglow with excitement. Often, she talks about the blue jay or the rose that she's working on, weaving glowing descriptions of the painting in and out through our conversation. Invariably, that moment of elation is followed by a crash midway through the painting. Although most often Marjolein is overflowing with verve when we speak, occasionally I've phoned to hear her answer my greeting with a forced response. By now, I've learned that the problem has nothing to do with my call. It's one of her "bad days"; she's halfway through a painting.

Missouri, January 2003

Midway, I have a moment of desperation—like a tightrope walker who has a moment of doubt. And then suddenly, the scent of nature comes to me, and there's the solution.

Slowly I work to make it come alive. It should always have breath in it. You should be able to touch it and feel it. Every hour it gets a little better. It seems as though the harder I work, the more life comes into it.

When I get back to the same feeling and the same excitement that I had when I started—the drawing is finished.

Meanwhile, Marjolein composes the text as she draws. "I'm always thinking about far too much text," she told me. But the words—whether they are a story or observation—are never an afterthought, they're part of the message. And, as with the prairie, there's the big picture and then also the focal points. Like the prairie,

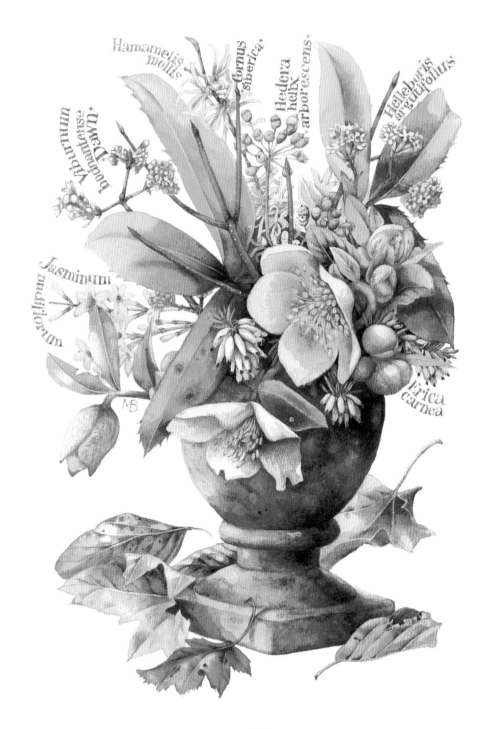

Hamamelis mollis

Cornus siberica.

Hedera helix arborescens.

Helleborus argutifolius

Viburnum bodnantense 'Dawn'.

Jasminum nudiflorum

Erica carnea

MB

Marjolein's illustrations are made up of brushstrokes, subtle shifts in color and balance. Like the prairie, each drawing has movement.

The analogy with the prairie doesn't end there: in the same way that the big bluestem, if given a beginning and a chance, if encouraged and stewarded through its formative stages, can now survive independently for generations and doesn't need Marjolein or mankind, Marjolein hopes that her art will transcend time and be forever. It is her legacy.

"I never cared if my work was in a gallery show," she once said. What is important to her is reaching a broad audience with her message. The robin, the blade of grass, the butterfly that we pass every day will become our intimate acquaintances because we've shared their secret moments through Marjolein. As she always says, she's just the interpreter; nature speaks to us all. So in all her drawings, in all her work, Marjolein repeats the same underlying message over and over again—in the bluebird, in the caterpillar, and in the wormy apple. "Stop and look," she says.

Missouri, January 2003

*For me, painting is always a discussion. I feel as though I'm very
close to people when I draw. They are walking beside me, they are
feeling the soft owl feather and hearing the song of the killdeer in
the tall grass. My drawing is my voice.*

Last Word

On my last visit to Missouri, I took an evening walk through the prairie. I walked past the pond and saw the last glimmer of glowing orange reflected in its waters. I went down on hands and knees and buried my nose in the ground ivy that Marjolein sniffs when she wants to inhale her childhood. I felt the softness of the mole tunnels underfoot and the gentle brush of the cool night air on my cheek. Even when I closed my eyes, I could sense the grasses stirring. I recognized the perfume of the night and heard the plaintive call of a hawk in the distance.

I'm a different person since I met Marjolein. I still don't know all the birds by sight or sound, but I know many more songs than before. When I see a meadow, even my own familiar goldenrod meadow in Connecticut, I peer past the grasses to examine the small-scale business of life going on at my feet. Now, when I walk in the fields, there's a pair of binoculars around my neck. I walk slowly. I stop and study poop. I expect that a skunk, or a fox, or a coyote, or a dragonfly might cross my path at any moment; you never know.

On my final late-evening walk in Missouri, I turned in the dusk toward the house and saw the light still shining in Marjolein's study. I could see Marjolein at her desk. She was bent over a drawing in the lamplight, adding the colors she knows by heart, bringing us closer to the robin's nests and spiderwebs that we pass by every day. Translating birdsongs into brushstrokes.

Missouri, September 2003

It's not only about learning from nature; it's about loving what you see.

To Dennis

Thanks to Marjolein and Gaston for their friendship; it has changed my life. Thanks also to: Sharon Polk of Fleishman-Hillard Inc, for getting us together; Anne Kostick, for her insight and editorial savvy; the Stewart, Tabori & Chang staff for their expertise and concern for details; designer Laura Lindgren; my agent, Colleen Mohyde, for her encouragement; Angela Dimmitt for her birding advice; Dr. Valerie Wright and the researchers at Konza Prairie; and Woody Woodward, Mark Spencer, Eileen Gaffen, and my friends at Hallmark for their enthusiastic support. Special thanks to Dennis Sega and Rob Girard for keeping the home fires burning while I traveled.

—Tovah

Published in North America by
Stewart, Tabori & Chang
115 West 18th Street
New York, NY 10011

Canadian Distribution:
Canadian Manda Group
One Atlantic Avenue, Suite 105
Toronto, Ontario M6K 3E7
Canada

Library of Congress Cataloging-in-Publication Data
Bastin, Marjolein
 View from a sketchbook: nature through the eyes of Marjolein Bastin with Tovah Martin.
 p. cm.
1. Natural history. 2. Nature. I. Martin, Tovah. II. Title.
QH81.B3195 2003
508—dc22

Designed by Laura Lindgren

ISBN: 1-58479-353-8

The text of this book was composed in Fournier and Seria Sans.

Printed in China

10 9 8 7 6 5 4 3

Stewart, Tabori & Chang is a subsidiary of

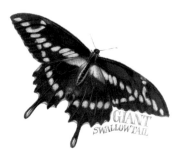

GIANT
SWALLOWTAIL